The Miegunyah Press

The general series of the
Miegunyah Volumes was
made possible by the
Miegunyah Fund
established by bequests
under the wills of
Sir Russell and Lady Grimwade.

'Miegunyah' was the home of
Mab and Russell Grimwade
from 1911 to 1955.

OUTBACK Cooking

ANDREW DWYER
with photography by **JOHN HAY**

THE MIEGUNYAH PRESS

THE MIEGUNYAH PRESS
An imprint of Melbourne University Publishing Ltd
187 Grattan Street, Carlton, Victoria 3053, Australia
mup-info@unimelb.edu.au
www.mup.com.au

First published 2008
Text © Andrew Dwyer, 2008
Images © John Hay, 2008
Design and typography © Melbourne University Publishing Ltd, 2008

Images in preliminary pages: pp. ii–iii, Campfire in Cooper Country, South Australia; pp. v, Simpson Desert sand dune, Central Australia; pp. vi–1, Swags at camp, Lake Eyre North, South Australia.

Front endpapers, clockwise from top left: Stir-fried beef with oyster sauce; Cockburn Range, WA; Braised fennel; aerial view of Pentecost River.

Back endpapers, clockwise from top left: Chicken breasts with sage and lemon; Andrew Dwyer in the outback; Bejah's rice; on the road with Andrew Dwyer.

Cover design by Phil Campbell
Text design by Phil Campbell
Printed in China through Australian Book Connection

National Library of Australia Catalogue in Publication data available from the National Library of Australia

'Australian history is almost always picturesque … It does not read like history, but like the most beautiful lies. And all of a fresh sort, no mouldy old stale ones. It is full of surprises, and adventures, and incongruities, and contradictions, and incredibilities; but they are all true, they all happened.'
Mark Twain, *Following the Equator*, 1897

Contents

Heading outback

Sit out in the desert after dark with the night air cool upon your back and your face to the life-giving heat of a fire. Stare into the glowing coals, let your thoughts wander, and you are touching the minds of all who have gone before you. Before we had language or cities or agriculture, we had fire. It gave us warmth and light and security, and, not least, it gave us something hot for dinner.

I make my living running off-road expeditions to the more rugged and remote parts of the Australian outback. There is something about the place that heightens all your senses. The light is clearer, colours more alive, and although it is often quieter than the city, every sound has meaning. After a day exploring this strange and ancient land, your sense of smell is strangely sharpened, your tastebuds curiously attuned, or to put it another way: you're absolutely ravenous. Bring together the best ingredients, prepare them with care, cook them fast or slow among the coals of a campfire, and you'll enjoy the best meal you've ever eaten.

It's partly being away from ordinary life in a land that's beautiful and different, but the fire, too, has a lot to do with it. Without it we could never have developed the art or science of cooking: it would all be just nuts, berries, leaves and raw meat. Yet, for what has seemed like good, practical reasons, we have turned away from the idea of cooking over an open fire.

In my home kitchen at Jamieson in the Victorian High Country, I have the luxury of two stoves. One is a stainless steel high-tech gas/electric convection number, the other a Rayburn slow-combustion wood stove. I use them both about equally, but for a special meal cooked to perfection, there's nothing as good as a griddle and a cast-iron pot on a fire built with the kind of dense, slow-burning wood you find lying around in the deserts of Central Australia. Cast iron distributes heat evenly. Camp ovens braise and roast at the same time. A carefully managed fire can be made to deliver anything from the gentlest of simmers to a searing heat unobtainable in any commercial kitchen. Food grilled over coals can be made to take on as much or as little of their unique smoky flavour as you desire. Campfire cookery is not hard, though it is useful to have advice about what to cook and the best way to go about it. I learned very early on that careful planning and preparation are the keys to cooking in the outback.

For my first trip I went down to the local fresh produce market and bought the best food I could lay my hands on. After a couple of days of rough travel the blood from the meat had mixed with the ice, the stone fruit was bruised, the greens had wilted, bottles had smashed, and the trailer had turned into a nasty mass of frothing food combinations. The bread went mouldy; all the wine glasses broke. At intervals an abraded beer can would explode as we bounced over corrugated roads. The wilderness teaches hard lessons: if I was going to serve the kind of food I had in mind, I was going to have to have a major rethink. I did.

I realised of course that perishable foods must be eaten first. So now at the beginning of a trip I usually serve seafood, poultry and plenty of greens, followed later in the trip by grains, pulses and root vegetables. I've written more detail about this in the tuckerbox section on page 8.

Opposite: Road through wildflowers on Cowarie Station, South Australia

Cooking on the trail

Cooking on an open fire is all about careful fire management. That means controlling the fire to make it do what you want it to. Any open fire will be subject to a variety of external influences: wind, air temperature, humidity and the degree of shelter. Then there is the wood to consider: is it dry or green, dense or light, aromatic maybe, or even poisonous? Safety issues can relate both to the environment—such as not starting a bushfire—and to people—such as ensuring there is a clear area around your fire with no logs sticking out to trip over. You may also need a supply of water, a hose, bucket or firefighting knapsack nearby in case the fire does something unexpected.

Let's start with the fire itself. I always light my fire in a cleared area, protected from the wind, away from any combustible items like dry grass or bushes that could ignite from embers or flying sparks. In most situations I don't cook directly on the fire, but will harvest coals using a long-handled shovel. This not only saves singeing my eyebrows and arm hair, but allows me greater control over the temperature. I always get the fire going as early as possible prior to cooking. One thing I never do is create a ring of rocks around the fire, as they get in the way of the shovel when it comes time to harvest coals, but I will sometimes place a windbreak upwind if needed. A sheet of corrugated iron and a couple of star pegs are ideal for this, but a pile of rocks or sand often has to do. In damp conditions fires can be hard to get going. I always try to keep some kindling dry, and in difficult circumstances, a splash or two of cattlemen's port (diesel) will get the dampest of firewood alight. *Never* use petrol or spirit, as the invisible vapour will explode. (Interestingly, the risk of this happening is greatest in cold conditions when there is little air movement.)

Selection of wood is always important. Obviously it will be dictated by what is available locally. Best is the kind of dense wood that grows in more arid areas, for example acacia, mulga and gidgee, and casuarinas such as bull oak. Light woods like pine burn fast and furious, but you will be left with few coals. Cypress pine is best avoided because its smoke will taint your food. I always find it a challenge cooking in the High Country with red gum, snow gum, box and mountain ash. No sooner do you remove the coals from the fire than they are black and cold. The coals of the dense desert wood glow for hours, retaining their heat. For smoking food, it is hard to go past red gum and apple gum.

Once you have your fire going and loads of hot coals, you can use the fire to suit your purpose. When I am grilling, I dig a rectangular hole about a metre by half a metre (about a yard by half a yard), and about 15 centimetres (6 inches) deep. Using a long-handled shovel, I fill the hole with ashes from the fire, then lay a sheet of reinforcing steel mesh over the top to grill on. Alternatively, an old fridge rack will do. Whatever you use, try to get something that fits over your trench to double as a barbeque as well as a pot rack, and make sure it's steel and not aluminium or alloy. One of my grates is made of steel mesh with folding legs. After cooking on cold desert winter nights, I shovel a few inches of sand over the fire pit, then roll my swag over it for the most sensational 'electric blanket'.

To cook in the camp oven, I usually lay a shovelful of coals on the ground, then place the camp oven on top of the coals. I then shovel a load of coals on the lid of the oven. The heat will radiate down and cook evenly. If you don't have the luxury of good wood, you may have to suspend the oven over a naked flame, or lay the oven near the naked flame and keep turning it, but this is not ideal. When I

want to check progress, I use a bushy branch to wipe the coals off the lid, make my inspection, then put more coals from the fire back on the lid. In very windy conditions I might dig a small pit, shovel a load of coals in, place the camp oven on top, then place a load of coals on the lid; to prevent the wind from overheating the coals, I'll add a shovel load of sand or dirt. If firewood is scarce or unavailable, you can always use heat beads, as pictured.

If I'm cooking in a wok, in most cases I light a small twig fire in a shallow depression not much larger than the width of the wok half buried. Once the fire is underway I will start cooking, and this will usually generate sufficient heat to finish the stir-fry. Make sure you use a wok with a handle. If I need a super-hot wok for dishes like Thai pak boong fei deng (page 148), I place two unburnt logs in a v-shape to corral the main fire, then place the wok above the naked flame at their point of junction, but this can be seriously hot work.

Always be aware of the safety issues with an open fire. It can be a wonderful servant, but makes a terrible master. Before turning in at night ensure the fire is secure, and be aware of the weather patterns. Never leave a fire unattended in case it gets out of hand and never light a fire on a day of total fire ban. When I have finished cooking I generally remove large logs from a fire and let the coals extinguish themselves. This is a better practice than burying the fire, as all evidence of the hearth will

generally be blown away by wind and washed away by rain, while a buried fire remains an eyesore. Remember that there is no visual difference between hot sand and cold sand, so make sure you don't create the risk of people burning themselves. Most accidents beside a fire take place with people tripping over protruding logs. Ensure your wood pile is away from the main fire, and if there are logs poking out, make sure they are easily identifiable and all point in the same direction.

Everything you need

All over the outback there are unique and ingenious contraptions invented for the purpose of cooking over an open fire. My mate Ian made a camp oven out of an old truck rim. It's great when you're catering for lots of people. Plough wheels have been popular barbecue grills since they were first invented. The Bell family, who once operated the Jamieson Timber Mill in Victoria, have designed a classic utensil for mega fry-ups. They drop three star pickets around their fire. Attached to each picket is a chain, from which is hung an old saw wheel with the teeth ground off. The heat of the grill can be adjusted by moving the chains up or down. You can fit two dozen eggs, fifty rashers of bacon and two dozen sausages on the saw-wheel grill plate all at once! Just the thing for feeding a team of hungry lumberjacks.

I generally don't need that kind of heavy artillery. What I consider the essentials are a grate, a good camp oven and a billy. For general frying I use a heavy cast-iron frying pan with a long wooden handle. I also have a very large steel pan with a section of hoop iron for a handle.

The camp oven originated even before the days of stoves. In the sixteenth century, the Dutch had refined methods of casting brass in dry sand moulds. The British improved on this process by baking the moulds, which resulted in a smoother cast. When these cast pots were distributed around the world, they were called Dutch ovens, presumably because of the origin of the method of manufacture. Cast-iron lidded pots or ovens are still called Dutch ovens in the United States, whereas in Australia they are called camp ovens. The Lodge Manufacturing Company in Tennessee—America's largest manufacturer of camp ovens—defines a Dutch oven as a camp oven with legs.

The thick cast-iron construction and heavy lids of camp ovens allow them to be buried in coals and sat on open flames. They can be used to boil, braise, roast and bake—in fact, you can cook almost anything in them, as well as boiling up old tea-towels too dirty for a simple wash. Look for an oven with a lip around the outside of the lid. This will help prevent ash from dropping into the oven when you lift the lid.

Before using your camp oven you need to cure it. Peel off any labels and remove any packaging. Fill the oven with boiling water, rinse and wipe dry with a towel. Coat the oven using a paper towel soaked in cooking oil. On a rack over a coal fire, or on a rack over a baking tray in the oven at home, heat the camp oven to 180°C (350°F) for at least one hour. Repeat the whole process a couple of times to achieve a black patina over the oven. This will proof the oven from rust and give

it a non-stick quality. As your oven ages with use, the pores in the cast iron will impregnate with oil. I can boil seawater in my twenty-year-old camp ovens and they don't rust. After use, wipe the inside of your camp oven with an oily rag. One disadvantage with camp ovens is that they are brittle, so I store mine in a hessian bag inside a plastic milk crate.

The stockmen on Bedourie Station in southwest Queensland overcame what they saw as the drawbacks of traditional camp ovens by designing their own: the Bedourie oven (pictured far left). Made of pressed spun steel, which is lighter, it can travel in a pack-saddle without breaking. It also has a lid with a lip that fits over the top, reducing the chances of ashes falling in and spoiling the food. It has hoop iron handles on the sides of the body as well as on the lid, which can double as a frying pan. I don't consider the Bedourie oven a replacement for a camp oven, but it's a very handy companion. Because they are thin, greater care must be taken to ensure the food doesn't burn. I like to braise vegetables and bake pizzas in a tray on a rack or trivet inside a Bedourie oven.

A rough guide to gauge the temperature of your camp oven is to place a piece of white paper towel in it. A moderate oven will turn the paper yellow; if the oven is hot it will be light brown; and if it is very hot the paper will turn dark brown.

It is useful to carry a couple of long hooks for lifting the lid off the oven, as well as a brush or bunch of branches to wipe hot coals off the lid. A long-handled shovel is invaluable for shovelling coals. Long tongs and long-handled wooden spoons are handy for reaching into the oven. The longer the handle, the easier to work around the fire.

Immortalised in the Australian poem *Waltzing Matilda*, the billy is the all-purpose Australian camp cooking tool. The name appears to have come from the Scottish 'bally', a milk pail. It is basically a large tin can with a length of No. 8 fencing wire attached as a handle. I not only boil water and make coffee and tea in them but use them for boiling spaghetti, making soups, custards and all manner of foods. You can hang the billy off a cast-iron tripod over the fire. This certainly has aesthetic appeal, but I tend to just lay the billy beside the fire on live coals.

To keep water hot, I use the bush hot-water system pictured (right). It works on the same principle as a domestic hot-water unit. Cold water is poured into the funnel at the top, and displaces hot water in the billy, which pours through the spout at the side. Because the billy is full of water, it can stay on the naked flame without melting and provides an eternal source of boiling water. A very handy device indeed!

The tuckerbox

Meticulous planning is essential when travelling into remote areas of the outback, and only two things are certain: distances will be long and roads will be rough. Depending on the time of year, temperatures may range from well below freezing to well above 50°C (122°F). Combine these factors with the absence of a well-equipped home kitchen, and outback cooks need a few tricks up their sleeves to produce delicious fresh meals. A well-stocked and well-packed tuckerbox or camp larder is one of those tricks. Consumer packaging is not designed to travel over corrugated roads, so you need to do plenty of repackaging and decanting before you depart. In a perfect situation it is best to group certain ingredients as to their order of use, to save having to unpack everything each time you go to the larder.

Try to use square containers; they pack better than round ones. Movement creates rubbing, which can cause containers to abrade and puncture, so pack everything tightly. Clean tea-towels make ideal packing, for as you use tea-towels you will also use up the items. Use plastic and metal, and avoid glass wherever possible. If you do pack glass, make sure it is immobilised and packed next to soft material. Screw-top square plastic jars are ideal for storing goods such as sugar, instant coffee, tea, herbs, nuts, bi-carb soda, couscous, salt and pepper and so on.

Ensure heavy objects are packed low, and lighter objects on top. Try to avoid taking soft drinks and beer in cans; their walls are so thin that a day or two on badly corrugated roads will cause them to abrade and burst. It is better to use glass. It is safer to store water in several smaller containers rather than in one large one.

Not all packing solutions for outback travel are available ready made. For glass bottles, lay some closed cell foam on the floor of a plastic tub. Pack the tub with upright lengths of 90-mm PVC water pipe and store your bottles in the tubes. As long as glass does not touch glass, your bottles will not break. Storing liquids in one tub ensures that if you do have a mishap, it is well contained. (I now only ever take beer in glass bottles, carefully packed.) Use bowls that nest and have multiple uses as either salad bowls or preparation bowls.

I have all my meat vacuum-sealed in plastic, including salamis, galantines and sausages; it will age superbly in your 12-volt fridge or icebox for at least two to three weeks. I have both, just in case the mechanical refrigeration breaks down. Although it lasts only five days in my icebox, I prefer crushed ice to block ice because it is more efficient at cooling. I open the icebox only when I absolutely need to, and try to keep the contents orderly so I know exactly where things are when I do open the lid. I prefer to store sealed goods like milk, yoghurt and drinks on ice, and vegetables in the 12-volt fridge. Roast beef is best after three weeks; if it starts to go green, a gentle wipe with some vinegar before cooking will remove any discolouration.

Store your green vegetables in stay-fresh bags, available in supermarkets. They will absorb the ethylene the produce gives off as it matures and significantly increase the shelf life of your greens. Snow peas will still be crisp in three weeks stored in these. Celery wrapped in aluminium foil keeps for weeks. Fresh basil, coriander and many leafy greens are best wrapped in wet paper towels and then placed in a plastic bag, and iceberg and cos lettuces are best wrapped in a damp paper towel and then aluminium foil. Oysters can be stored unopened in a hessian sack for days, and also store well if shucked when placed in a plastic jar with their brine for up to three days on ice.

Pulses and grains will store for years, and after a couple of weeks out, it's time to break open the root vegetables—potatoes, carrots, celeriac and beetroot. Spring onions will not tolerate moisture

and need to be kept dry. Asian people have mastered the art of drying foods such as sea vegetables, seafood and mushrooms, which makes these foods ideal to take camping, remembering, though, that reconstituted dried foods work best in dishes where they are mixed with fresh ingredients.

Bread is always difficult to transport. The factory-made white sliced loaf is stale within a couple of days. If you must eat that kind of bread, wrapping it in foil and then plastic helps—or freeze it. I find that hand-shaped sourdough bread baked in a wood oven has the best staying power. If kept dry it should still be good for toasting after a couple of weeks, even if you have to pick the occasional spot of mould out of the crust. After that, it's time to rise (or prove) dough on the dashboard of the car using the heat of the sun through the windscreen, to bake later in the camp oven; or better still, make a damper in the ashes.

Food also must be protected from wildlife. The worst campsite marauders are semi-tame possums, wallabies and kangaroos who have learnt the art of skilfully extracting food from tents, backpacks and plastic containers. On a remote camp on the Gunbarrel Highway I once had a dingo come into camp in the early hours and drag a giant sack of muesli 200 metres away. Why it went for the muesli I have no idea, but its tenacity was extraordinary. At the other end of the predatory scale, ants will attack sugar within minutes. Australia has more species of ants than any other country on earth; every time a myrmecologist (a person who studies ants) goes into the outback they discover new species. Flies are another nuisance. If one blowfly gets into the trailer-fridge because someone's left the door open, the crew'll be complaining about maggots in their rations. During the warmer months I often wait until after the sun has gone down and the flies have stopped buzzing before commencing food preparation.

Environmental conditions often determine menu planning. Water-hungry dishes such as pasta and boiled root vegetables can be prepared only when water is available. Roasts don't require any water, and in dry camps we have often satisfactorily cleaned our dirty dishes using sand. Weather conditions and the quality of firewood often have a bearing on what I will prepare, so it is not always possible to stick to the menu plan.

Some of the recipes in this book call for a food processor or blender. I use a 12-volt inverter in my vehicle to power a blender in the bush; you can do the same, or take a mortar and pestle. Alternatively, there are some things you can prepare in advance of the trip. Again, it just takes a little planning.

Twelve-day outback expedition

Here is a sample menu for a trip into the outback, followed by a list of provisions to take and how to pack them. The outback environment presents many challenges, and food hygiene is one of them. The scope of this section does not detail standard food health and hygiene issues. Ensure that your food groups are separated in storage and preparation. The suggestions here make the assumption that travelling in remote regions will place constraints on the food preparer not associated with those experienced in the home kitchen.

Night 1 Lemon chicken with couscous and rocket salad
Night 2 Kangaroo with quandong chilli glaze, Cajun camp oven potatoes, green salad
Night 3 Blackened chicken with onion marmalade and sweet potato
Night 4 Chipotle eye fillet with pico de gallo
Night 5 Spaghetti tossed with sun-dried tomatoes, fennel and blood orange salad
Night 6 Gang jued (no-taste soup), rice in the camp oven, spicy blachan beans, wok-seared wheels of corn with kecap, pak boong fei deng
Night 7 Garlic roasted leg of lamb with anchovy and rosemary, ash-roasted potatoes, braised fennel
Night 8 Tempeh kecap with rice in the camp oven
Night 9 Kidman camp oven roast beef with bedourie braised vegetables, barm damper
Night 10 Puy lentil cassoulade with Italian pork sausages
Night 11 Stir-fried beef with oyster sauce, rice in the camp oven
Night 12 Spaghetti with the sweetest tomato sauce

Provisions

Meat

Whole chicken, chicken fillets, kangaroo saddles, eye fillet, pork, leg of lamb, beef topside, diced oyster blade or topside, Italian sausages, pancetta. Have your butcher vacuum-seal all these. Best to double-bag the leg of lamb in case the bone tears the plastic.

Dairy

Butter can be put in sealed plastic containers at the bottom of the fridge. Milk in plastic bottles should be wrapped in plastic wrap—never trust the commercial packaging. Milk and butter can both be frozen prior to departure. Once the fresh milk has expired move on to UHT, but wrap each UHT packet thoroughly in plastic wrap and store separately from everything else—these packets breach easily and make a terrible, smelly mess to clean up. Store cheese in the warmer section of fridge, wrapped in greaseproof paper in a sealed plastic container. Store tempeh in its original packaging in the fridge or icebox.

Fruit and vegetables

In dry storage: garlic, onions, potatoes, sweet potatoes, sweet corn in husks, lemons, limes, oranges, dried quandongs.

In cold storage: chillis (in stay-fresh bag), tomatoes (pack so they don't bounce around or rub against each other), fennel, flat-leaf parsley, rocket, red peppers, snow peas and string beans (all washed and dried thoroughly, then put in stay-fresh bags), water spinach (wrapped in damp paper towel, then put in a stay-fresh bag).

Fresh herbs
Coriander (wash and dry thoroughly, then wrap in damp paper towel and put in a stay-fresh bag), rosemary and bay leaves (store in stay-fresh bags).

Dried herbs and spices
Cayenne pepper chipotle, chilli powder, sweet paprika, cumin, oregano and garlic powder (store in plastic containers), blackening spice (mix before leaving, store in sealed plastic container).

Condiments
Olive oil (best to buy in a tin and store upright, wrapped in plastic wrap in case the lid leaks), stock (liquid stock in cardboard packaging needs to be wrapped several times in plastic wrap as it hates corrugated roads; frozen stock should be used within three or four days), balsamic and red wine vinegar, kecap manis, soy sauce, nam pla, sesame oil and oyster sauce (store in original glass bottles in PVC tubing), kudzu and palm sugar (store in plastic bags), salt and pepper (decant into plastic containers), tomato paste (in tins; other packaging tends to rupture).

Store cupboard ingredients
Flour, lentils and rice (screw-top plastic containers), sun-dried tomatoes (in sealed screw-top container, they are slippery things that like to escape), Kalamata olives (in a screw-top plastic container in their brine, then wrapped tightly in plastic wrap in case the lid comes loose).

No cookbook can be entirely original. We all pinch and build on each other's ideas: it's the sincerest tribute one cook can pay another and it's the way cuisine has developed around the world. That said, a goodly proportion of the recipes in this book I hit upon by chance, using an unusual combination of ingredients out of necessity, then developing the idea. Other recipes have been inspired by people I truly admire, such as Adelaide chef Cheong Liew, with his sublime combinations of Asian and European flavours; or Tim Love of the Lonesome Dove Bistro in Fort Worth, who has created a weird but brilliant mix of traditional cowboy chow and contemporary Texan cooking.

The recipes in this book are guaranteed bullet proof. If they work in the harsh conditions of the outback, they'll do just fine in your kitchen, though you'll miss the smoky flavour of an open fire, and trying to replicate its searing heat indoors can be risky. So whenever you get the chance, pack up your camping gear, head into the outback and take this book with you.

Starters

Cantonese sweet corn soup

2 tablespoons oil
2 spring onions, finely chopped
1 tablespoon grated ginger
2½ cups (20 fl oz) chicken stock, heated
4 large corn cobs grated or 2 × 420 g (15 oz) cans creamed corn
2 tablespoons soy sauce
½ cup (4 fl oz) water
1 tablespoon cornstarch
1 tablespoon sesame oil
1 egg
1 teaspoon oil
½ teaspoon salt
1 tablespoon rice vinegar
white pepper
spring onions for garnish

Heat the oil in a saucepan and fry the spring onions and ginger briefly until aromatic. Add the stock and corn. Bring to the boil, then simmer for as long as it takes you to prepare the cornstarch mixture. Add soy sauce to taste.

In a cup, mix the water, cornstarch and sesame oil to a smooth paste and stir in a little of the soup, a classic Chinese technique. Stir this mixture into the soup to thicken.

In a cup or a small bowl, lightly beat the egg together with a teaspoon of oil and ½ teaspoon salt. Stir this into the soup to create white strands.

Add vinegar and season with salt and pepper.

Come and get it
Ladle soup into a bowl. Sprinkle with chopped spring onions.
Serves 4

Previous pages: Red Gorge, northern Flinders Ranges, South Australia

Fire-grilled artichoke stuffed with garlic and Parmesan

In the depths of winter the first globe artichokes start appearing on the market shelves. These edible flowerbuds are from the thistle family, and tend to frighten off the uninitiated; however they are very popular all over the world, and also with my guests in the outback, to whom I serve them whenever they are in season. Driving north from Adelaide heading towards the outback, you pass through the lush market gardens of the Adelaide plains. Here, Italian immigrants have established vineyards and olive groves, and among the magnificent market gardens there are whole fields of artichokes.

Artichokes contain the chemical cynarin which, while being good for the liver, has the peculiar phenomenon of making everything you taste after it sweet, with a hint of back-palate bitterness. The result is not unpleasant, kind of like the salt/sugar combination so favoured by fast-food manufacturers. Make sure you use stainless-steel utensils when cooking artichokes, as iron or aluminium will create an unsightly but harmless blue staining.

This recipe is a favourite of mine. It is the essence of simplicity, yet the flavour balance is complex. It is suited to the outback, because the idea is to pull the flavoured flower petals through your teeth and toss the inedible bits over your shoulder.

1 globe artichoke per person
shaved Parmesan cheese
2 cloves garlic per person
sea salt
freshly ground black pepper
¼ cup (2 fl oz) olive oil per person

Drink suggestion
Best to drink water.

Cut the head of the flower off the artichoke, and with scissors remove any of the sharp points on the outer petals. Leave the stem on. If you need to do this more than 10 minutes before you are going to cook this dish, store the artichokes in a bowl of acidulated water (add the juice of one lemon to 1.2 litres (40½ fl oz) of water) to stop the artichokes from discolouring.

With a potato peeler, shave flat strips of Parmesan. Peel and roughly chop the garlic.

Stuff the Parmesan and garlic liberally between the petals of the artichoke all the way to the choke (heart).

Sprinkle with salt and pepper and pour olive oil into the heart. Place upright in a bowl while you prepare the others.

Grill the artichokes over coals, turning regularly until blackened all over and the cheese has melted through.

Come and get it
Place on a plate and serve—yum! If you are dining inside it would be advisable to provide finger bowls and bowls in which to put the discarded bracts—unless you are happy with your dinner guests chucking their scraps over their shoulders.

Gang jued (No-taste soup)

For almost a decade my sister Sally owned The Boathouse Restaurant at Bo Phut on the island of Koh Samui in the Gulf of Thailand. French windows opened onto a beach fringed with coconut palms. Fishermen cast their nets from rustic wooden fishing boats just off the shore, and in the distance the blue peaks of Koh Phangan rose abruptly from the placid waters of the Gulf. I will never forget this idyllic scene, enhanced by the music of Brian Eno's *Another Green World*, a couple of glasses of Thai whisky served on the rocks with half cola and half soda water, finished with a squeeze of fresh lime juice, and a bowl of this magnificent and simple soup. Far from the tropics, on the searing ironstone plains of the outback, if the going gets tough and I need to put a meal together quickly, this is the one. Somehow, no matter how difficult the conditions, the taste of this soup takes me back to that peaceful paradise.

1 litre (2 pints) cold water
3 cloves garlic, smashed
1 cup (8½ fl oz) nam pla
250 g (9 oz) ground pork
3 tablespoons extra nam pla
3 cloves garlic, minced
2 cups chopped greens (Asian greens, spinach, cabbage or lettuce)
1 cup fresh coriander leaves

Bring the water to the boil and add the smashed garlic and cup of nam pla. Allow to simmer for 5 minutes.

Mix the ground pork, the extra nam pla and minced garlic together and shape into small balls about 2½ centimetres (1 inch) in diameter.

Drop the balls into the soup and cook for 5 minutes. Add chopped greens and stir for 30 seconds. Add fresh coriander and serve immediately. Serves 4

Drink suggestion
Thai whisky soda cola, of course!

Lambs' brains wrapped in prosciutto with aïoli

Fussy teenagers turn their nose up at them, dinner guests will often politely pass on the invitation, but seriously, brains are a true delicacy, much loved by the cognoscenti. They have a magnificent smooth texture and delicate flavour. They take a little preparation, but it is well worth the effort. This dish borrows from the old tradition of crumbed brains with bacon, but marries the soft texture of the brains with the crispy saltiness of deep-fried prosciutto and a rich garlic aïoli.

6 sets of lambs' brains
1 tablespoon lemon juice
12 thin slices prosciutto
500 ml (1 pint) extra virgin olive oil
1 tablespoon salted capers or 2 spring
 onions sliced into thin strips
 (optional)
sage leaves

Always use brains that are absolutely fresh. If you buy them frozen, only thaw them before you are ready to cook them. Soak the brains in lightly salted water for 3 hours. Change the water a couple of times. While the brains are soaking, make the aïoli.

Carefully peel the skin and membrane off the brains and remove any blood. Soak again for 1 hour in the refrigerator in a bowl of water with a tablespoon of lemon juice. Remove from the water and towel dry.

Run a knife down the middle of each set of brains to divide them in two. Carefully wrap each brain half in a slice of prosciutto and secure with two toothpicks.

In a heavy pan, heat the olive oil to 190°C (375°F). Gently immerse wrapped brains (two at a time) and cook until prosciutto is crispy and brown. Remove to a paper towel.

Drop rinsed and dried capers or spring onions in hot oil briefly and remove to a paper towel.

Aïoli
16 cloves garlic
4 egg yolks
500 ml (1 pint) best extra virgin
 olive oil
1 tablespoon lemon juice
salt
freshly ground pepper

Aïoli
Crush the garlic in a mortar until it is a smooth paste. Blend in the egg yolks with a spoon until they are well combined.

Place the mixture in a bowl. While whisking, start adding the best extra virgin olive oil, drop by drop at first, then in a slow stream. Stop adding oil when the sauce has the thick consistency of a mayonnaise. Add lemon juice and season with salt and pepper.

Come and get it
To plate, spoon 2 tablespoons of aïoli in the centre of a plate. Stack three of the wrapped brains on top, then scatter capers, spring onions or sage leaves on top and serve immediately. Serves 4

Wine suggestion
A nutty, salty Spanish Manzanilla sherry

Savoury pita crisps with three dips

The pita crisps in this recipe are North African–inspired, but feel free to experiment yourself as there are endless permutations. For example, try an Italian mix, using fresh and dried oregano and tomato paste, or an Indian version using curry spices. Just use your imagination. These dishes are great to start a party rolling. The crisps will keep for weeks in a sealed plastic container, and are very tasty in the back country with a glass of wine while watching the sun go down.

Savoury pita crisps

500 g (1 lb) butter
½ cup (4 fl oz) olive oil
4 cloves garlic, finely chopped
1 teaspoon sea salt
1 tablespoon tomato paste
1 tablespoon sweet paprika
1 tablespoon ground cumin
1 tablespoon ground coriander
1 teaspoon caraway seeds
5 pitas split into single layers

Beetroot dip

6 large beetroot
3 cloves garlic, finely chopped
1 teaspoon chipotle chilli powder—
 or smoked paprika
1 teaspoon coriander seeds, roasted
 and ground
1 teaspoon cumin seeds, roasted and
 ground
1 teaspoon salt

Savoury pita crisps

Gently heat the butter, olive oil, garlic and salt in a saucepan until the butter has fully melted. Add the tomato paste and stir well to incorporate with the oil. Add herbs, spices and caraway seeds and simmer gently for 5 minutes.

With a pastry brush, paint the textured (inner) side of the pita liberally and grill until crisp. Be careful, as pita goes from crisp to burnt very quickly. Allow to cool, then break with your hands into dipping-sized pieces.

They can be served fresh and warm, or you can store them in a sealed plastic container in a cool place until ready for use.

Beetroot dip

Trim the stems from the beetroot but leave the skin and tapering root intact (this helps maintain the deep colour of the beetroot while it's being cooked). Fill a saucepan with cold water to cover the beetroot and bring to the boil. Allow to boil gently until the beetroot is cooked. They should be soft enough so that a skewer can be pushed through them. It should take 1–1½ hours.

Run the beetroot under cold water and remove the skins and tapering root. Chop into chunks about 2½ centimetres (1 inch) in size.

Place the garlic and spices in a blender and process, gradually adding the beetroot until there is a smooth consistency. Add salt to taste.

Previous pages: Glen Helen, Western
MacDonnell Ranges, Central Australia

Black olive tapenade

The name tapenade is derived from the French Provencal word *tapeno* (caper), and this magnificent black olive, anchovy and caper-based condiment has many variations and uses. Spread it on toast or bruschetta, mix it with hard-boiled eggs and serve it with fresh tomatoes on toast. Toss it with steamed baby potatoes. It is great with fish and poultry. I even serve it with roast lamb or eye fillet of beef. It is great to have on hand, and I usually prepare some in advance before leaving on a trip. You can store tapenade for weeks in the refrigerator. Place it in a jar and cover with some extra virgin olive oil. A traditional tapenade has equal quantities of tuna and anchovies, and does not include fresh herbs.

120 g (4 oz) canned anchovies
4 cloves garlic, peeled
1 cup fresh chopped parsley
2 sprigs fresh rosemary
120 g (4 oz) capers
juice of one lemon
1 teaspoon Dijon mustard
freshly ground pepper
1 cup black pitted olives (I like to
 use Kalamata)
½ cup (4 fl oz) olive oil

Wash the anchovies in cold water and drain them, then place all the ingredients except half the olives and the olive oil in a blender. Blend to a smooth paste, gradually adding the olive oil.

Once a smooth paste is attained, add the remaining olives while pulsing the machine so the paste has some chunky olive pieces.

Pesto

4 cloves garlic, crushed
salt to taste
2 cups sweet basil leaves
15 g (½ oz) walnuts
30 g (1 oz) pine nuts
1 cup (8½ fl oz) extra virgin olive oil
60 g (2 oz) Parmigiano-Reggiano,
 finely grated
20 g (½ oz) Pecorino Sardo, finely
 grated
freshly ground black pepper

Pesto

Process the garlic with the salt in a blender. Add torn basil leaves and blend. You may have to stop and stir a couple of times. Add the walnuts and half the pine nuts, and blend while pouring in the olive oil in a steady stream. Add the remainder of the pine nuts and pulse briefly so they are still chunky. Stir in cheese and pepper.

Come and get it

Arrange dips in individual bowls on a tray and surround with pita crisps.

Spicy beef and chicken satay

250 g (9 oz) beef sirloin or flank
250 g (9 oz) chicken fillet
3 tablespoons sugar
1 tablespoon yellow curry powder
⅓ cup (3 fl oz) nam pla
3 tablespoons coriander leaves

Peanut sauce

1¾ cups (14 fl oz) coconut milk
2 tablespoons red curry paste
¼ cup (2 fl oz) nam pla
3 tablespoons white sugar
1 cup crunchy peanut butter

Drink suggestion

A lovely light ale like Cascade Pale
Ale from Australia's oldest brewery,
Cascade in Tasmania

Cut the beef and chicken into long strips about 7½ centimetres long (4 inches), 2½ centimetres (1 inch) wide and ½ centimetre (¼ inch) thick.

In a deep tray or large bowl mix the sugar, yellow curry powder, nam pla and coriander leaves thoroughly. Place the meat in the mix and leave in the refrigerator to marinate anywhere from 15 minutes to 24 hours. Make the sauce while the meat is marinating.

Thread the meat onto wooden skewers that have been soaked in water for at least an hour. Grill over a gentle flame for 5 minutes on each side.

Peanut sauce

Combine all ingredients in a saucepan and simmer for 15 minutes. Make sure you stir the sauce constantly.

Come and get it

Place the sauce in a bowl for dipping and serve along with satay skewers of meat. You may wish to add some slices of cucumber as an accompaniment. Serves 6

Artichokes with pinzimonio

The name *pinzimonio* is derived from the Italian *pinzare*, to pinch or clamp, and *monio* from *matrimonio*, marriage. It's all about pinching the vegetables (not the bride) and mixing the olive oil dip. Make sure the olive oil is the best you can find. A cynic would suggest pinzimonio is little more than a vinaigrette, but little is wrong; it is so much more. Concentrate on the ingredients and the care you put into making pinzimonio and it won't be just a vinaigrette—it will be pinzimonio!

3 garlic cloves
¾ cup (6 fl oz) best extra virgin
 olive oil
¼ cup (2 fl oz) red wine vinegar
sea salt
freshly ground black pepper
1 globe artichoke per person

Crush the garlic cloves and steep them in the olive oil for an hour or so, then remove. Add the vinegar and season with salt and pepper. Mix until the oil and vinegar are completely combined.

Place cold water and salt in a stainless-steel saucepan and bring to the boil. Add artichokes and boil until tender (between 20 and 30 minutes).

Come and get it
Once cooked, the stems, petals and heart can all be dipped in the pinzimonio and eaten. Pinzimonio is also a great dip for raw vegetables, such as fennel, radicchio, mushrooms or celery, or chunks of crusty Italian-style bread, such as casalinga or ciabatta, or a flavoursome sourdough.

98 DARWIN

30 ALICE SPRINGS

AYRES ROCK / 450 MARLA (NEW 'TRACK' ROUTE)

DALHOUSIE THERMAL PONDS (WITJIRA NATIONAL PARK)

MT. O'HALLORAN LOOKOUT

OODNADATTA (AS HALF ALIVE AS EVER!)

OCKENDEN SPRING

ALGEBUCKINA RAIL BRIDGE & WATERHOLE

BIRDSVILLE via 'FRENCH TRACK' / 195 'ALLANDALE' CATTLE STATION

WARRINA RUIN & ELDERS MONUMENT

PEAKE MONUMENT (W.C. GILES) EXPLORER

CHAMBERS PILLAR (4WD) / via FINKE & OLD 'GHAN' TRACK

KULPINNA / 105 'PEAKE' CATTLE STATION

PERTH	3020
BRISBANE	2442
SYDNEY	2190
MELBOURNE	1780
PORT AUGUSTA	600
WILPENA POUND (FLINDERS RANGES)	500
MARREE (BIRDSVILLE TRACK END)	220
LYNDHURST (STRZELECKI TRACK END)	300
LAKE EYRE STN. LOWEST AREA IN AUSTRALIA	135
CALLANNA, HARRIMANNA, FETTLERS COTTAGE RUINS	
BUBBLER & BLANCHE CUP - ARTESIAN SPRINGS — TURN OFF AT	
BIRDSVILLE via BIRDSVILLE TRACK	740
COWARD SPRINGS FLOWING BORE & RUINS	75
STRANGWAYS EL. BORE, BERESFORD EL. BORE, CURDIMURKA R. BORE	
STUART CK' CATTLE STN.	135

THIS SIGN WAS ERECTED TO COMMEMORATE THE CONNECTION OF S.T.D. PHONES TO CATTLE STATIONS & TOWNS IN THE 'OODNADATTA TRACK' AREA IN JUNE 1987...

MUDMAP KEY
THE OODNADATT - TRACK - MARREE to MARLA

CONGRATULATIONS!
YOU'VE REACHED THE MIDDLE OF THE MOST INTERESTING AREA OF THE OODNADATTA TRACK...

KULGERA, ALICE SPRINGS & AYRES ROCK, FINKE

NORTHERN TERRITORY

SOUTH AUSTRALIA

WITJIRA NATIONAL PARK

DALHOUSIE

MARLA

SIMPSON DESERT (PARALLEL SANDHILLS)

OODNADATTA

STUART (BORING!) HWY.

COOBER PEDY (ONLY)

YOU ARE HERE

WILLIAM CREEK

MARREE

SOUTH TO THE FLINDERS RANGES

Beef

Kidman camp oven roast beef

It is fitting that this great Australian beef dish be named after the Cattle King.

8 small brown onions, peeled but
 left whole
½ bottle good-quality red wine
2 kg (4½ lb; football-sized piece)
 good, tender topside, dressed
1 cup (8½ fl oz) water
5 cloves garlic
¼ cup unbleached white flour
Dijon seeded mustard
sea salt
freshly ground black pepper

Place a bed of peeled onions on the base of camp oven. Add red wine to cover the onions.

Wash the topside in cold water and pat dry with a clean tea-towel. Peel the garlic but leave the cloves whole. Make 1-centimetre (½-inch) incisions around the topside and insert a clove of garlic into each.

Rub the topside with flour, add a liberal coating of Dijon mustard, salt and pepper. Place the topside on top of the onions.

Place a lid on the camp oven, place it on a bed of coals and cover with a shovel load of coals. Baste every 15 minutes and top up the juices with a 50/50 mix of wine and water. Alternatively, place the camp oven in a conventional oven at 200°C (390°F).

Remove the roast short of the temperature times given below, and rest under a clean tea-towel. This allows the meat to retain the juices in the fibre when you carve it.

I would rather provide meat thermometer temperatures than oven times, as there are so many variables, including the shape and thickness of the meat, and whether you are in the mountains or the tropics.

Wine suggestion
Traditionally you should have a cup of black tea, but a McLaren Vale Maglieri Shiraz would be nice.

Cooking time per kilo (2 lb)		Internal temperature
Rare	30–40 minutes	60°C (140°F)
Medium	40–50 minutes	70°C (160°F)
Well done	40–60 minutes	75°C (170°F)

Often you will just want to spoon the juices from the oven over the beef. However, if you wish to create a sauce, once you have removed the meat to rest, pour the remaining fluid from the camp oven into a sauté pan, add a knob of butter and reduce. Serves 6

Horseradish sauce
2 teaspoons of ground horseradish
1 tablespoon of cream
¼ teaspoon of sugar

Horseradish sauce
Simply combine the ingredients.

Previous pages: Drover mustering cattle in outback South Australia

Camp oven osso buco with gremolata

Osso buco means 'bone with the hole' and the dish originated in Milan. Ideally, you want to use the veal shin from the hind leg, as it has more meat. Only use the part of the shank that has meat surrounding the whole bone, and ideally use shins from a very young beast, preferably not more than three months old. Traditionally, this osso buco is served with risotto alla Milanese, which is arborio rice cooked with saffron and Parmesan cheese; however, I like to serve it with boiled polenta. If ever there was a dish never to eat in summer, this would be it, but on a still, cold desert night when the stars are blazing, the frost is settling in the hollows and you don't want to be too far from the glow of the fire, this is the perfect dish to warm the cockles of your heart.

4 osso buco (5 cm/2 inches thick)
½ cup plain, unbleached white flour
pinch each of salt and pepper
⅓ cup (3 fl oz) olive oil
5 tablespoons unsalted butter
¼ cup (2 fl oz) dry white wine
340 g (¾ lb) tomatoes, chopped
6 cloves garlic, coarsely chopped
½ cup (4 fl oz) pint veal or
** chicken stock**

Tie each osso buco with a piece of string so it will retain its shape when cooking. Season the flour with salt and pepper and lightly flour the meat on each side, leaving the edges. An easy way to do this is to put seasoned flour in a bag, add the meat and shake.

In a large sauté pan, heat the olive oil and butter and cook the osso buco until browned on both sides. Remove and stand.

Pour the wine into the pan and and let it simmer until it reduces by a third. Add tomatoes and garlic and cook gently for 5 minutes.

Place each osso buco upright in the base of a camp oven so the marrow does not fall out while cooking. Pour the contents of sauté pan over the top and add the stock.

Cook gently for at least 2 hours with the lid on for the first hour, and ajar for the second. While it's cooking, prepare the gremolata.

Gremolata
handful of chopped parsley
2 gloves of garlic, very finely chopped
grated zest of 2 lemons (no white pith
** whatsoever!)**

Gremolata
Mix the parsley, garlic and lemon zest together. If you like you can prepare the three at once, chopping them together on a board.

Come and get it
Place the cooked osso buco on top of polenta or rice and spoon the cooking sauce over the top. If the sauce is too thin you can reduce it in the camp oven on a high heat while leaving the osso buco to stand. Sprinkle gremolata over the top. Serves 4

Wine suggestion
Go for the big, gutsy red—a Barossa Shiraz.

Opposite: Hans Heysen Trail, Wilpena Pound, Flinders Ranges, South Australia

Chipotle eye fillet with pico de gallo

3 tablespoons chipotle chilli powder
2 tablespoons sweet Spanish paprika
1 tablespoon garlic powder
½ teaspoon sea salt
7 tablespoons olive oil
4 × 225 g (8 oz) eye fillets

In a bowl, mix the chipotle chilli powder, paprika, garlic powder and salt with 3 tablespoons of olive oil. Liberally coat the eye fillets and leave at room temperature for anywhere from 10 minutes to an hour.

While the meat is marinating, make the pico de gallo.

Heat a cast-iron pan until very hot and add 4 tablespoons of olive oil. When the oil is smoking, place the fillets in the pan and sear for 90 seconds on each side, turning once. Use tongs to turn the meat; do not pierce the flesh or the juice will evaporate, leaving the meat tough.

Transfer the steaks to a preheated camp oven or oven preheated to 180°C (350°F) for 4 minutes for medium rare.

Pico de gallo

6 medium tomatoes, finely diced into
 cubes
1 white onion, finely diced into cubes
juice of 4 limes
3 red chillies, finely chopped
1 cup finely chopped coriander
4 tablespoons olive oil
sea salt
freshly ground black pepper

Pico de gallo

Combine all ingredients and season with salt and pepper. Leave to stand for at least 10 minutes for flavours to infuse.

Come and get it

To serve, place the steak on a plate, pour oven juices over the top, and place three to four tablespoons of pico de gallo next to it.
Serves 4

Wine suggestion

Try a robust Zinfandel—it's closer to the American south-west that inspired this dish!

Eye fillet of beef with parsnip and potato mash and truffle Kalamata olive paste

4 × 250 g eye fillet
3 teaspoons olive oil
1 teaspoon freshly ground
 black pepper

You can make the olive paste in advance, then while the mash is cooking, prepare the meat.

Coat the whole fillet in the olive oil and freshly ground black pepper and stand at room temperature for 10 minutes.

Grill on a hot grill for 4 minutes on each of the four sides of the fillet.

Parsnip and potato mash

500 g (1lb) parsnips, peeled and
 chopped
500 g (1lb) potatoes (Desiree, Nicola
 and Pontiac are good), peeled
1 tablespoon butter
milk to moisten
salt and pepper

Parsnip and potato mash

Boil the parsnip and potatoes in salted boiling water for 20 to 25 minutes until soft. Drain and pass through a potato ricer or mash well with a masher. Add the butter and sufficient milk to moisten. Season with salt and pepper. Beat until nice and fluffy.

Truffle Kalamata olive paste

1 cup pitted Kalamata olives
½ cup (4 fl oz) olive oil
1 teaspoon white truffle oil
2 cloves garlic, finely chopped
½ cup flat-leaf parsley
3 tablespoons capers, rinsed
2 sprigs fresh rosemary
2 sprigs fresh thyme

Truffle Kalamata olive paste

Reserve half the olives, the olive oil and the truffle oil. Blend all the other ingredients in a blender. Gradually add the olive oil in a steady stream. Add the remaining olives and pulse so some of them remain in chunks. Stir in the truffle oil.

Come and get it

Slice the beef across the grain into serves. Spoon the mash onto plates, place the eye fillet on top of the mash and top with olive paste.
Serves 4

Wine suggestion

A King Valley Nebbiolo

Grilled rib eye on a bed of skordalia with wilted bok choy

4 × 400–450 g (14–16 oz) rib eye
 steaks (these are big steaks!)
¼ cup (2 fl oz) olive oil

Skordalia
500 g (1 lb) potatoes (Desiree, Nicola
 and Pontiac are good), halved or
 quartered
8 cloves garlic, crushed
2 teaspoons salt
fresh ground white pepper to taste
1 cup (8½ fl oz) extra virgin olive oil
2 tablespoons white vinegar

Wilted greens
16 baby bok choy or large bunch choi
 sum, roughly chopped
2 tablespoons peanut oil
2 cloves garlic, roughly chopped
2 tablespoons nam pla
1 tablespoon light soy sauce
3 tablespoons oyster sauce
4 tablespoons chicken stock or water
1 teaspoon dark sesame oil

Wine suggestion
A complex Mallea Cabernet
Sauvignon Shiraz from Coonawarra

First, prepare the potatoes and start the skordalia. Grill the rib eye to your taste. While the rib eye is grilling, prepare the wilted greens.

Skordalia
Bring a large pot of water to the boil, add the potatoes and garlic and cook until very soft, which should take about 10 to 20 minutes. Drain, peel the potatoes and mash with cooked garlic until smooth.

Stir the salt and pepper into the potato, then slowly add the olive oil while stirring with a wooden spoon. Make sure the olive oil is completely incorporated. Stir in the vinegar and season.

Keep the skordalia warm in a covered bowl. What you don't use with the steak you can serve with crusty bread or crackers, or add to a mezze platter.

Wilted greens
While the rib eye is grilling, thoroughly wash the greens in cold water to remove any grit.

Heat the peanut oil in a wok. When it is smoking, add the garlic and stir for 30 seconds. Before the garlic goes brown, add bok choy, nam pla and soy, and stir rapidly for 1 minute. Add the oyster sauce, stir to incorporate and add stock or water. When the greens have wilted through and are a nice fluorescent green colour, add the sesame oil.

Come and get it
Serve the rib eye on a plate with the skordalia and wilted greens on the side. Serves 4

Stir-fried beef with oyster sauce

This was one of the first Cantonese dishes I ever learned to cook as a young teenager. The salty caramel of the oyster sauce and the sweetness of the onion combine perfectly, even though in ancient China, Buddhists considered onion *wu han*, one of the 'five forbidden odorous foods'.

My favourite oyster sauce is the Thai Maekrua brand. It is not too salty and contains oyster extract, and while it has no preservatives it lasts forever without refrigeration, making it ideal to take to the desert. I use it with many different braised meats and in stir-fries, especially with cauliflower and broccoli. I have stripped this dish to the bare essentials and it works really well, but remember the most important thing is to have a really hot wok. If you are cooking outdoors, place the wok on a naked flame, as coals will not provide sufficient heat.

275–350 g (10–12 oz) beef steak, such as topside
3 cloves garlic
4 tablespoons light soy sauce
3 medium-sized brown onions
¼ cup (2 fl oz) peanut oil
2 cups cauliflower cut into small florets (optional)
6 tablespoons oyster sauce

Wine suggestion
Go for a Pinot Noir.

Slice the beef as the Chinese do: across the grain, into long, thin slices.

Peel the garlic and slice thinly. Mix the soy sauce and garlic in a bowl, add the meat and coat it thoroughly. Leave to stand for 1 hour.

Peel the onions, then slice them vertically into quarters so the layers peel away to make petals. Heat the wok to very hot. Add 2 tablespoons of the peanut oil and stir-fry the onion petals until they are showing small black charred areas. Remove immediately to a bowl and set aside.

If you are using the optional cauliflower, stir-fry the florets now for a couple of minutes, then set aside.

Add the remaining peanut oil to the hot wok, stir for a couple of seconds, then add the beef. Stir-fry until the beef just changes colour. Add the cooked onions and cauliflower and stir while adding the oyster sauce. You don't have to be too accurate with the amount of oyster sauce—it's better guessed than measured. Just tip from the bottle until a nice sauce consistency is achieved.

Come and get it
Once everything is well blended, transfer it to a serving bowl, or plate individually into bowls on top of steamed rice. Serves 4

Suzie's mince and tomato

I learned to make this dish as a teenager and have taught it to my children—they call it *Chinese Bolognese*. The sweetness of the sugar, ground beef and tomatoes with the salt of the soy make this very popular with children. It is so simple to prepare it makes a great dish for students and home-leavers. Because of its simplicity, it is also good to serve out on the trail.

2 tablespoons peanut oil
4 cloves garlic, finely sliced
500 g (1 lb) minced beef
6 large tomatoes, chopped
½ cup white sugar
6 tablespoons light soy sauce

Wine suggestion
A dry, limey Riesling

Heat the wok and add the peanut oil. Toss the garlic quickly in the oil and add the mince before the garlic browns. Brown the beef, stirring constantly. Add the tomatoes, sugar and soy, stirring constantly. Cover, reduce heat and simmer for 15 minutes.

Come and get it
Serve on top of steamed rice. Serves 4

Tunisian meatballs with tabouleh and baba ghanoush

The baba ghanoush is especially good if you can cook the eggplants on coals, for that extra-smoky flavour. I use a 12-volt inverter in my vehicle to power a blender in the bush, but for years I used to grind with a mortar and pestle to make the baba ghanoush—a labour of love. For this recipe, make the tabouleh and baba ghanoush before you start the meatballs. If you like a bit of heat, you can make the harissa too.

Tunisian meatballs
500 g (1 lb) finely ground beef
1 brown onion, chopped
1 tablespoon ground cumin
1 teaspoon ground coriander
½ teaspoon cayenne pepper
1 cup coriander leaves
4 tablespoons oil

Tabouleh
¾ cup burghul
1 cup (8½ fl oz) lemon juice
3 large red tomatoes
1 cucumber
⅓ cup (3 fl oz) lemon juice
salt and pepper
¼ cup (2 fl oz) olive oil
1 tablespoon extra virgin olive oil
4 cups chopped flat-leaf parsley
4 spring onions
4 red radishes, finely chopped
½ cup fresh mint, finely chopped

Tunisian meatballs
Place the meat, brown onion, cumin, coriander, cayenne pepper and coriander leaves in a blender and process until it becomes a smooth sticky paste.

Wet your hands to stop the paste from sticking to them, and roll into small balls 2½ centimetres (1 inch) in diameter.

Heat the oil in a sauté pan and fry the balls until golden brown. Drain on kitchen paper.

Tabouleh
Put the burghul in a bowl and cover with lemon juice. It will soak up the lemon juice, so you may have to add more water to keep the burghul immersed. Leave to soak from 1½ hours to overnight. When soft, drain any excess fluid. The burghul will triple in size. Place the burghul on a clean tea-towel to dry.

Cut the tomatoes in half, squeeze gently to remove any excess seeds, then chop finely. Cut the cucumber in half lengthwise, remove the seeds by running a teaspoon down the centre, and dice into small cubes.

To make the dressing, combine the lemon juice and salt and pepper and whisk, gradually adding the olive oil and extra virgin olive oil.

Put the burghul in a large salad bowl, add all the salad ingredients and toss well. Pour the dressing over the burghul and toss.

Previous pages: Aboriginal stockman mustering cattle, South Australia

Baba ghanoush

3 eggplants
3 cloves garlic
1 teaspoon salt
freshly ground black pepper
1 teaspoon ground cumin
⅓ cup (3 fl oz) lemon juice
2 tablespoons tahini
1½ tablespoons olive oil
1 tablespoon chopped flat-leaf
 parsley
smoked Spanish sweet paprika

Harissa

110 g (4 oz) dried red chillies
12 cloves garlic, peeled and chopped
1 teaspoon salt
1 tablespoon ground cumin
1 tablespoon ground coriander
1 teaspoon ground caraway seeds
1 tablespoon dried mint
½ cup (4 fl oz) olive oil

Wine suggestion
A well-blended Cabernet Merlot

Baba ghanoush

Place the eggplants on coals or on a grill and blacken the skins. Keep cooking until they shrivel and are cooked through, turning with tongs and being careful not to break the skins. Alternatively, you can bake the eggplants in an oven at 200°C (400°F). Remove to a plate and allow to cool.

When cool, peel the skin off the eggplants and discard. Squeeze out any excess moisture and bitter juices and chop the flesh.

With a fork, mash the garlic and salt to a paste on a plastic board so you retain the garlic oil.

Put the eggplant flesh, garlic, pepper, cumin, lemon juice, tahini and olive oil in a blender and process until smooth and creamy.

Season with salt and stir in the parsley. You can make this in advance as it will keep in the refrigerator for several days. When serving, sprinkle paprika on top.

Harissa

Chop the chillies and cover with boiling water. Leave to soak for 1 hour, then drain.

Process the chillies, garlic, salt, spices and herbs with 2 tablespoons of the olive oil until a thick paste forms.

Spoon into a sterilised jar and cover with the remaining oil. If the jar is properly sterilised, this should keep in the refrigerator for six months.

Come and get it

Place the meatballs on a plate, spoon alongside a serve of tabouleh and a serve of baba ghanoush and harissa if you like.
Serves 4

Opposite: Aerial view of a cattle muster on a station in outback South Australia

Game

Camel korma

The word korma means 'braise', and this dish is wonderful and succulent, as the meat is slowly cooked in the camp oven. The best camel meat is from a young bull camel, and for this dish I prefer the chuck. Camel meat is tender and flavoursome.

1 teaspoon cumin seed
1 teaspoon coriander seed
1 teaspoon cardamom seed
6 cloves
water
8 cloves garlic
2 cm (1 inch) cube ginger root
1½ teaspoons salt
½ teaspoon cinnamon
1 kg (2 lb) camel meat, cut into
 2½ cm (1 inch) cubes
2 tablespoons all-purpose flour
4 tablespoons peanut oil
2 brown onions, sliced into rings
½ teaspoon garam masala
2½ cups plain yoghurt
2 tablespoons coriander leaves

Wine suggestion
A Chardonnay with vanilla and butterscotch notes

Combine the cumin seed, coriander seed, cardamom seed and cloves in a blender and grind to a fine powder. Add ⅓ cup (3 fl oz) of water, garlic, ginger root, salt and cinnamon and blend to a paste.

Dust the camel meat in the flour, brown it in a camp oven in 1 tablespoon of the oil, then set it aside.

Place 3 tablespoons of the peanut oil in the camp oven and cook the onion rings, stirring until they are transparent and starting to brown. Add the spice paste and stir for a couple of minutes. Add ½ cup (4 fl oz) of water and simmer for 1½ hours.

Stir the garam masala into the yoghurt, then add the yoghurt mix to curry and stir for a couple of minutes.

Come and get it
Pour curry into serving bowls over steamed rice and top with coriander leaves. Serves 4

Previous pages: Four-wheel drive convoy at dusk, Blinman–Wilpena Pound Road, Flinders Ranges, South Australia
Right: Aboriginal rock art, Kakadu, Northern Territory

Grilled emu with port and aniseed glaze

Ubiquitous across the continent from rainforest to desert, the emu is a curious creature with poor eyesight. The female lays her eggs then departs, leaving the male to hatch and raise the chicks. Arid zone ecologist John Read wrote in his excellent book *Red Sand, Green Heart* that the emu can do two things: it can run and it can think—but it can't do them both at once!

2 cloves garlic, crushed and chopped
1 teaspoon ground cardamom
1 teaspoon ground coriander
⅓ cup (3 fl oz) raspberry vinegar
500 g (1 lb) emu fillets

Port and aniseed glaze
3 cups (25 fl oz) beef stock
3 cloves garlic, crushed and chopped
2 teaspoons mustard-seed oil
1 cup (8½ fl oz) port
3 star anise

Wine suggestion
A Pinot Noir from the Jamieson Valley

Mix all the ingredients and marinate the emu fillets for 2 hours at room temperature. While they're marinating, make the glaze.

Port and aniseed glaze

In a saucepan, reduce the beef stock gently by two-thirds.

In another saucepan, fry the garlic in 1 teaspoon of the mustard-seed oil until it's just starting to brown. Pour in the port and beef stock and add the star anise. Reduce again by two-thirds on a gentle simmer.

Preheat the camp oven to 220°C (430°F). Brush a cast-iron skillet with the mustard-seed oil and heat until very hot.

Cook the emu fillets for 1 minute on each side, then transfer to the heated camp oven. Bake for 5 minutes.

Transfer to a plate, cover with a clean tea-towel and allow the meat to stand for 5 minutes.

Come and get it

Place warm emu fillets on a plate and top with the glaze. Serves 4

Kangaroo with quandong chilli glaze

While this dish uses quintessential Australian ingredients, you may substitute others, such as venison for the kangaroo and dried apricots instead of quandongs. You can use fresh, frozen or reconstituted dried quandongs (which are best reconstituted in port or orange juice). If you don't have a quandong tree in your backyard, you can buy them from bush-tucker suppliers. *Kudzu*, or *kuzu*, is a Japanese thickening agent that can be purchased from Asian stores. You can substitute cornflour or arrowroot, but kuzu does yield a superior result.

2 loin saddles of kangaroo
3 tablespoons olive oil
4 cloves garlic, chopped
chillies to taste, julienned
1 cup quandongs, thinly sliced
250 ml (8½ fl oz) veal or beef stock
2 teaspoons palm sugar
2 teaspoons kudzu
½ cup (4 fl oz) cold water
salt to taste

Wine suggestion
Sparkling Burgundy

Coat the kangaroo saddles in olive oil and leave to stand for a few minutes.

Heat a dry pan on the fire until it's red hot. Throw in the saddles and sear on each side for about a minute to 1½ minutes each side. Expect the olive oil to flame when it contacts the pan. Once seared, transfer the fillet to a preheated camp oven and cook for a further 10 to 15 minutes. When the meat is cooked, place it on a board and leave to stand for at least 10 minutes. While it's standing, make the glaze.

Return the same frying pan used for searing the meat into the fire and heat. Add the chopped garlic and the chilli and fry for a minute or so. Add the quandongs and fry for a further couple of minutes. Pour the stock and any juice from the camp oven into the pan and stir. Reduce this over the heat for a few minutes—it's quite okay to allow it to boil. You may wish to sweeten this with a couple of teaspoons of sugar. Palm sugar is by far the best, as it is not as harsh as white sugar and will retain the subtle tartness of the quandong. Mix the kudzu with the water, pour into the pan and stir until thickened. Add salt to taste.

Come and get it
Slice the kangaroo in medallions across the grain, fan onto a plate and top with a couple of spoonfuls of the glaze. Serves 4

Jaquie's seared wild duck breast with olive oil and herbs

Wild duck is magnificent to eat when the proper technique is used. You do need to apply the rules for cooking game rigorously when it comes to duck. Fast and furious or slow and gentle—nothing in between. (Jaquie, who first showed me how to cook this dish, reckons you should only sear the breasts for as long as it would take the duck to fly through her kitchen!) This dish is the essence of simplicity, yet with a quality bird it will provide a truly memorable dining experience.

1 tablespoon fresh oregano
4 sage leaves
2 tablespoons fresh parsley
1 teaspoon fresh rosemary
4 tablespoons extra virgin olive oil
4 wild duck breast fillets
2 tablespoons olive oil
sea salt
freshly ground black pepper

Roughly chop all the herbs and mix them in a bowl together with the extra virgin olive oil. Marinate the duck breast fillets for at least 1 hour.

Heat a cast-iron skillet until it's very hot, and pour in the olive oil. Remove the duck breasts from the marinade and slide them onto the skillet, seasoning them with salt and pepper. Sear for 2 minutes on each side. When you turn the breasts, add the marinating herbs and oil. The breasts should be medium rare and tender.

Wine suggestion
Sparkling Shiraz

Come and get it
Slice the fillets into medallions, place on a plate and top with pan juices. Serves 4

Previous pages: Galahs in Parachilna, South Australia

Spinifex quail with sage and rosemary

Of the many creatures that inhabit the vast spinifex grasslands, none is more endearing nor, I almost regret to say, tasty as the quail, of which there are several species. A walk through the spinifex in the evening will often flush out quail. If you are lucky you will occasionally see a mother quail with a procession of chicks the size of your thumb following along behind.

8 quail
6 cloves garlic, crushed
sea salt
freshly ground pepper
8 pieces of lemon zest (no white pith)
4 large sprigs fresh rosemary
2 tablespoons butter
2 tablespoons olive oil
16 sage leaves
bitter greens, such as radicchio
 and endive

Wine suggestion
A clove and aniseed Pinot Noir from New Zealand

Rub inside the cavities of the quail with crushed garlic, sea salt and pepper. Insert a piece of lemon zest into each quail.

Finely chop two of the sprigs of rosemary, leaving the other two as sprigs. Melt the butter and olive oil in the base of a camp oven. Add all of the rosemary and sage leaves and cook until the sage leaves are crisp. Watch that the temperature does not get too hot; you want the butter to remain a golden-brown colour. Remove the sage leaves and reserve.

Gently turn the quail in the butter. Be careful not to sear them as they will become dry and tough.

Place the lid on the camp oven and cook gently at 200°C (390°F). After 6 minutes, turn the quail over and roast them on the other side for a further 6 minutes.

Remove the quail from the oven and rest for a couple of minutes on a board under a clean tea-towel.

Come and get it
Place quail on top of the bitter greens. Pour pan juices and scatter sage leaves over the top. Serves 4

Wild rabbit with porcini mushrooms

1 wild rabbit
½ cup unbleached plain white flour
salt
freshly ground black pepper
½ cup (4 fl oz) olive oil
6 cloves garlic, chopped
6 large fresh tomatoes or 2 large tins
 tomatoes
1 teaspoon tomato paste
1 cup dried porcini mushrooms
¾ bottle dry white wine—don't use
 cheap plonk
6 large parsley stems

Wine suggestion
Chardonnay

Peel the membrane from the rabbit and soak it in a bucket of salt water (1 cup of salt per bucket) for up to 24 hours. Chop the rabbit into pieces and dust with flour seasoned with salt and pepper. Brown the rabbit pieces in half the olive oil in a heavy pan. Remove and drain on kitchen paper.

Fry the garlic in the remaining olive oil until fluffy and aromatic, add tomatoes, tomato paste and stir till well mixed. Stir the mushrooms into the mix, then add the rabbit portions.

Slowly pour in the wine until the rabbit is covered, stirring gently. Add the parsley stalks and place on a very low flame. Cook for 3 to 5 hours with the lid on, stirring occasionally. Season to taste.

Come and get it
Serve on grilled polenta or saffron papardelle (wide ribbon pasta).
Serves 4

Stuffed wild duck

2 wild ducks
juice of 2 lemons
sea salt
1 brown onion, diced
1 stick celery, diced
1 carrot, diced
1 apple, cored, peeled and diced
2 tablespoons walnuts, chopped
2 tablespoons Worcestershire sauce
1 teaspoon freshly ground black
 pepper
8 rashers bacon

Place the ducks in a large bowl and cover with water and the lemon juice. Soak the ducks for 15 minutes, then remove them and dry with paper towels. Rub them inside and out with a little salt.

Mix the onion, celery, carrot, apple, walnuts, Worcestershire sauce and pepper together in a bowl. Fill the cavities of the ducks with the stuffing and seal with either toothpicks or metal skewers. Wrap the duck with the bacon rashers.

Place a couple of centimetres (an inch) of water in the bottom of a camp oven and bake with the lid on at 160°C (325°F) for at least 1 hour, or until the duck is tender.

Remove the lid and the bacon, increase the oven heat to 180°C (350°F) and baste the duck every few minutes until it has browned.

Wine suggestion
An earthy, gamey Pinot Noir

Come and get it
Cut the ducks in half with a vertical incision down the breastbone. Place, with stuffing, on a bed of wild rice. Serves 4

Sugar-cured grilled kangaroo

6 kangaroo top-side steaks
125 g (4 oz) sea salt
125 g (4 oz) white sugar
6 sprigs thyme, roughly cut (stems
 included)
white pepper

Wine suggestion
A peppery Shiraz

Remove silver skin and any fat from the steaks, then coat them with a mixture of the salt, sugar, thyme and pepper. Place the steaks on a cake rack on a tray, cover with plastic wrap and leave in the refrigerator to cure overnight.

Wash the steaks under cold running water and towel dry. Cook them on a hot grill for a couple of minutes on each side until medium rare. Remove them to a warm plate, cover with a clean tea-towel and let them rest for 5 minutes.

Come and get it
Slice the meat into medallions and lay on a plate with some potatoes and salad on the side. Serves 6

Wild duck with juniper sauce

2 wild ducks, plucked, cleaned and
 quartered
juice of 2 lemons
2 tablespoons olive oil
12 juniper berries, crushed
1 tablespoon fresh rosemary, finely
 chopped
1 tablespoon finely chopped fresh
 thyme
⅓ cup (3 fl oz) cognac

Wine suggestion
Pinot Noir

Soak the duck pieces in the lemon juice (mixed with enough water to cover them) for at least an hour. Remove and dry with paper towel.

Brush the duck pieces with oil and lay them in a warmed and greased camp oven. Place the lid on and bake at 160°C (325°F) for 15 minutes. Remove the ducks from oven and drain the oven of any fat.

Add the rest of the ingredients and cook, stirring for 5 minutes. Return the ducks and place the lid back on the camp oven. Roast until the ducks are done, basting every 10 minutes. It should take around 40 to 60 minutes.

Come and get it
Serve on a bed of wild rice with the juice and berries on top of the ducks. Serves 4

Poultry

Blackened chicken with onion marmalade and sweet potato

This ever-popular dish has a great blend of flavours, looks impressive and has a festive character. The chicken is coated in a delicious savoury spice, complemented by the nutty smooth sweet potato and the sweet onion marmalade. I use grain-fed chickens that are truly free-range from Kangaroo Island in South Australia. You can substitute fish for the chicken—snapper is good; it also works with certain oily fish such as tuna and swordfish, but any firm white fish is fine. This dish needs to be cooked on a very hot, dry cast-iron griddle. It is best cooked outdoors on a naked flame, as you need to heat the pan for 10 to 15 minutes to get it seriously red hot. If you cook it inside, open all the windows and disconnect your smoke alarms, as this dish will smoke out the house. For this recipe, start the onion marmalade and mash before cooking the chicken.

Blackened chicken
4 chicken breast fillets
blackening spice (recipe below)

Blackening spice
¼ teaspoon fresh thyme
¼ teaspoon fresh oregano
¼ cup salt
2 tablespoons cayenne pepper
2 tablespoons paprika
1 tablespoon onion powder
1 tablespoon garlic powder
2 teaspoons dried basil
¼ teaspoon ground mustard
⅛ teaspoon ground cloves
2 tablespoons freshly ground black pepper
½ teaspoon salt

Blackened chicken
Wash the chicken and dry with a paper towel.

Spread the blackening spice on a plate and press the chicken onto it to coat it thickly on one side.

Heat the griddle or cast-iron pan until very hot. Do not oil.

Drop the chicken into the pan with the side coated in the blackening mix down. Sear until the blackening mixture has started to blacken and two-thirds of the chicken flesh has turned white.

Turn the chicken and cook on the other side until the chicken is cooked white through. Test the chicken with a skewer. If the juice that runs is pink, the chicken is not ready. When the juice is clear, remove to a plate with a spatula.

Blackening spice
Toast the fresh herbs in an oven until semi-dry, then grind them in a mortar and pestle, adding all the other blackening spice ingredients. Mix well.

Previous pages: Water-logged claypan,
William Creek–Coober Pedy Road,
South Australia

(continued over)

Onion marmalade

6 brown onions
½ cup (4 fl oz) olive oil
2 bay leaves
1 tablespoon finely chopped fresh
 rosemary
1 tablespoon balsamic vinegar

Sweet potato mash

4 medium-size sweet potatoes
water to cover
2 teaspoons cumin
1 teaspoon salt

Wine suggestion

A crisp, tingling Colombard

Onion marmalade

Peel the onions and slice into thin rounds.

Heat the olive oil in a saucepan and add the onions, bay leaves and rosemary. Stir constantly for 15 minutes until the onion is soft and sweating. Add the balsamic vinegar, then cover the pot and simmer for a further 15 minutes. Stir again until the onions caramelise and turn a rich brown colour.

Sweet potato mash

Peel and chop the sweet potatoes into 5-centimetre (2-inch) blocks. Place them in a pot and cover with cold water. Bring to the boil, turn down heat and boil until they are soft.

Remove the sweet potatoes from the water and mash with cumin and salt. Return the mash to a dry saucepan and keep warm on a gentle flame, stirring occasionally to prevent it sticking to the bottom. This recipe should yield around ½ cup of mash per person.

Come and get it

Place half a cup of sweet potato mash in the centre of a plate. Spoon half a cup of onion marmalade on top of each serve of sweet potato, then place the chicken on top. You may like to garnish with a slice of lemon, some deep-fried parsley or shallot, or some sprigs of fresh thyme. Serves 4

Lake Eyre salt-baked chicken in a wok

Surrounded by the dunes of the Simpson Desert to the north and the Tirari Desert to the east, Lake Eyre bakes in searing summer temperatures consistently above 49°C (120°F). Once every twenty years, great floods come down the massive river systems of the Diamantina, the Georgina and Coopers Creek and fill the lake. With the floods come seabirds such as cormorants and pelicans to feed on the exploding fish population. For a few brief months you can watch waves crash on the shore, smell the sea breeze as seagulls circle, and you would swear you were standing by the ocean. Then gradually the rivers stop flowing and the lake dries up, returning to the 'vast desolate waste' described by nineteenth-century explorer John Edward Eyre, the first European to sight the lake.

There are estimated to be 400 million tonnes of salt on the surface of Lake Eyre. When the lake is dry, you can walk out onto this crust. On a moonless night it is particularly surreal with the starlight of the Milky Way reflecting off the salt. It is as if you have been transported to outerspace. You can watch stars rise on the absurdly flat horizon. The salt deposited in Lake Eyre is the equivalent of 80 years' worth of commercial salt production in Australia. Often when I visit I use its salt for this dish. Surprisingly, the salt crust seals the moisture into the chicken and makes a delightful meal. The yellow rice wine and dried lotus leaves are available from Asian food stores.

2 cloves garlic, finely chopped
2 tablespoons grated ginger
1 teaspoon sugar
1 teaspoon yellow rice wine
1 teaspoon white pepper
4 scallions, chopped
1¼ kg (2¾ lb) chicken
4 dried lotus leaves
4 tablespoons peanut oil
4 kg (9 lb) coarse salt

Wine suggestion
An amontillado sherry

Mix the garlic, ginger, sugar, rice wine, white pepper and scallions together. Rub the mixture all over and inside the chicken and leave for 1 hour.

Place the lotus leaves in a bowl and pour boiling water over them so that they soften. Dry the leaves on paper towels, then brush with peanut oil. Wrap the chicken in the leaves.

Heat the salt in a wok for 15 minutes, then make a well in the salt large enough in which to bury the chicken. Insert the wrapped chicken and cover with hot salt. Cook for 30 minutes.

Carefully lift the chicken from the salt, turn it over, and bury it again. Cook for a further 30 minutes.

Come and get it
Discard the lotus leaves, slice the chicken and serve on steamed rice. Serves 6

Christmas turkey stuffed with chestnut and wrapped in prosciutto

I remember as a child at school we used to sing an Australian Christmas carol that went:

The north wind is tossing the leaves, the red dust is over the town;
The sparrows are under the eaves, and the grass in the paddock is brown . . .

The north wind in summer feels as though it is blowing straight out of the furnaces of hell. I knew what the red dust was, but I'd never been to where it came from, picked up by great dust storms in the outback hundreds of kilometres to the north and carried in by the north wind.

I know many Australians still sit down to a traditional Christmas dinner more suited to the depths of winter. Roast turkey with all the trimmings followed by Christmas pudding on a boiling hot day feels to me like overdoing it. I prefer to serve this turkey dish. It is festive and kind of traditional; however, with a crisp green salad it is not as stodgy and doesn't slow you down as much as the full Christmas catastrophe.

Turkey

1 whole turkey, boned
½ cup (4 fl oz) olive oil
20 slices prosciutto
stuffing (recipe below)

Stuffing

350 g (12 oz) peeled chestnuts (fresh or tinned)
2 cups (17 fl oz) milk (if using fresh chestnuts)
3 slices white bread, crust removed and torn into small pieces
1 large brown onion, finely chopped
¼ cup fresh chopped parsley
¼ cup fresh chopped sage
50 g (1⅔ oz) butter, melted
1 egg, beaten
sea salt
freshly ground black pepper

Turkey

First make the stuffing. With the turkey placed skin-side down, place the stuffing in a log shape on top of it, roll the turkey up and tie off with butcher's string.

With your hands or a pastry brush, wipe the turkey with some of the olive oil, then lay slices of prosciutto all over the roll so there is no turkey flesh exposed.

Place the rest of the olive oil in a baking dish or camp oven and add the wrapped turkey. Roast in a moderate oven at 180°C (350°F) until the turkey is cooked—usually 1½ to 2 hours, depending on the size.

Remove the bird to a carving board and cover with clean a tea-towel while you make the sauce.

Stuffing

If using fresh chestnuts, simmer them in milk until they are tender. Strain and mash to a puree.

In a bowl, mix the chestnut puree with the bread, onion, herbs, butter and egg. Season with salt and pepper. If the mixture needs more moisture, add a little of the milk in which you boiled the chestnuts, or if you used tinned chestnuts, just add a little milk.

Sauce

2 tablespoons plain flour
1 cup (8 ½ fl oz) Chardonnay
1 teaspoon chopped sage
1 teaspoon chopped parsley
salt and pepper

Wine suggestion

Sparkling Shiraz

Sauce

Sprinkle plain flour into the baking tray or camp oven and with the turkey juices and olive oil stir with a wooden spoon over gentle heat, scraping any crunchy bits and mixing well.

When brown, add the wine. Add herbs and stir. Season with salt and pepper to taste.

Come and get it

Remove the bird to carving board and, carving across, cut it into 2-centimetre (¾-inch) slices. The resulting effect is almost like a roulade, with the rolled turkey meat spiralling through the stuffing.

Pour the sauce over the turkey. The food police would tell you to discard the crunchy prosciutto, but I serve it on top of the turkey. Serves 6

Chicken breasts with sage and lemon

This dish borrows from a traditional Italian veal dish, scaloppini, but substitutes chicken for the usual veal. I love the blend of the lemon and sage with a lovely grain-fed chicken fillet. While sage is said to have originated in Syria, it rapidly spread through the Mediterranean, primarily as a medicinal plant. As the Romans used to say: *Cur moriatur homo cui salvia crescit in horto?* (Why should the man who has sage growing in his garden ever die?)

In Germany it is used with oily fish, and in the Middle East in all kinds of salads.

4 chicken breast fillets
½ cup (4 fl oz) extra virgin olive oil
¼ cup (2 fl oz) freshly squeezed
 lemon juice
1 cup (loosely packed) fresh
 sage leaves
sea salt
freshly ground black pepper
12 thin slices of lemon
50 g (1⅔ oz) butter

Marinate the chicken fillets in half the olive oil and half the lemon juice in a bowl with sage, a pinch of salt and freshly ground black pepper. Leave for 1 hour, then remove and pat dry, reserving the marinade.

Heat the rest of the olive oil in a cast-iron pan. Gently cook the lemon slices and remove. Add the butter and sauté the chicken fillets gently until they start to brown. Add sage leaves from the marinade and cook for 5 minutes. Add the remaining marinade and cook for a further 2 minutes. Remove the chicken and reduce the marinade for 2 minutes.

Wine suggestion

An aged Riesling

Come and get it

Place the chicken on a plate, putting the lemon slices and sage leaves on top. Pour the pan sauces over the lot. Serves 4

Deep-fried whole chicken in an Asian vinaigrette

Combine the crispness of a deep-fried chook with this traditional Chinese vinaigrette and you have a marriage made in the Middle Kingdom!

1½ kg (3⅓ lb) chicken
2 scallions, finely chopped
2½ cm (1 inch) knob of ginger,
 finely grated
1 tablespoon mirin
1 tablespoon light soy sauce
1 teaspoon salt
5 litres (5 quarts) peanut oil

Asian vinaigrette
3 scallions, finely chopped
2½ cm (1 inch) knob of ginger,
 finely grated
3 tablespoons light soy sauce
2 tablespoons chicken stock
1 tablespoon sesame oil
½ tablespoon hot chilli oil
2 tablespoons rice vinegar
2 tablespoons sugar

Wine suggestion
An older South Australian Riesling
or full-bodied Burgundian style
Pinot Noir

Put the chicken into a large bowl or pan. Mix the rest of the ingredients except the peanut oil into a marinade and pour over the chicken and inside its cavity. Allow to stand for 1 hour.

Heat the peanut oil to 180ºC to 190ºC (350°F to 375°F) in a deep fryer or large heavy pot. Immerse the chicken whole and fry until crisp and brown. This will take around 25 to 30 minutes.

While the chicken is cooking, make the vinaigrette.

Mix all the vinaigrette ingredients together in a bowl. Be sure to mix thoroughly so that the sugar dissolves.

Come and get it
Chop the chicken into bite-sized pieces and place in bowl. Pour the vinaigrette over the chicken and toss. Serve on a plate with steamed rice and cucumber slices. Serves 6

Lemon chicken with couscous

A wonderful summer dish, this chicken cooks beautifully in a Bedourie oven.

1 whole chicken
10 lemons
6 cloves garlic, roughly chopped
1 cup finely chopped flat-leaf parsley
2 tablespoons olive oil
1 teaspoon sea salt
1 teaspoon freshly ground
 black pepper
1 teaspoon cayenne pepper
bitter greens, such as radicchio
 or endive

Wine suggestion
A light Italian Frascati

Slice the chicken straight down the breast bone and open out flat.

Juice the lemons and reserve the skins.

Make a marinade by mixing the chopped garlic, lemon juice, ¾ cup parsley, olive oil, salt and pepper together. Marinate the whole chicken in the refrigerator for at least 1 hour.

Place the chicken in a baking dish or camp oven. Pour in the marinade then sprinkle with cayenne pepper. Place the lemon halves, cut surface down, on top of the chicken to cover it.

Roast at 180°C (350°F) for 45 minutes, basting at 15-minute intervals.

Remove the lemon halves and return to the oven for a further 15 minutes.

While the chicken is cooking, prepare the couscous according to the recipe on page 100.

Come and get it
To carve the chicken, run a knife down the backbone to split it in two, then cut each side into thirds.

Place a small pile of couscous on the plate. Pour 2 to 3 tablespoons of the lemon sauce from the camp oven into the couscous, top with a piece of chicken and pour on another spoon of sauce. Sprinkle with fresh parsley and serve with a salad of bitter greens. Serves 6

Previous pages: Private road into North Moolooloo Station, Flinders Ranges, South Australia

Lime duck noodle salad

This dish combines the Chinese classic of duck, ginger and cucumber, but adds a hint of Thailand with the limes and chilli. While it is a bit time consuming, it is a great summer dish.

2 x 2 kg (4½ lb) ducks
½ teaspoon salt
½ teaspoon pepper
2 limes
4 slices ginger

Rub salt and pepper into the cavities of the ducks. Prick the limes several times with a toothpick or skewer, and insert one into each of the ducks. Insert 2 slices of ginger into each duck.

Place the ducks in a pan and bake in an oven or a camp oven at 180°C (350°F) for 1½ hours, removing any fat that accumulates in the pan or camp oven every 15 minutes.

While the duck is cooking, make the dressing.

As the duck cools, reserve the skin to make the garnish and cut the meat from the bones.

Lime dressing

2 teaspoons grated ginger
2 cloves garlic
1 cup (8½ fl oz) chicken stock
2 tablespoons soy sauce
⅓ cup sugar
¾ cup (6 fl oz) lime juice
1 teaspoon lime rind
1 small red chilli finely chopped

Lime dressing

Mix all the dressing ingredients together and gently heat in a saucepan for 10 minutes. Remove from the heat and allow to cool. When the dressing is just warm, toss the warm duck meat and dressing together in a bowl. Leave to cool to room temperature, then cover and place in the refrigerator.

Garnish

duck skin
4 tablespoons peanut oil
2 tablespoons finely chopped mint
6 spring onions, finely chopped

Garnish

Cut the duck skin into thin strips. In a sauté pan, heat the peanut oil and fry the duck skin until it is crisp. Remove to greaseproof paper and allow to cool. In a bowl, mix the cool duck skin, mint and spring onions, then prepare the noodles.

Opposite: Pink Roadhouse, Oodnadatta, South Australia

Noodles

½ tablespoon sesame oil
¼ cup (2 fl oz) rice vinegar
1 tablespoon soy sauce
¼ cup sugar
1 tablespoon peanut oil
1 teaspoon grated ginger
1 red chilli, finely chopped
2 continental cucumbers, peeled
 and diced
500 g (1 lb) glass noodles

Wine suggestion

A crisp, limey Riesling

Noodles

Thoroughly mix the sesame oil, rice vinegar, soy sauce and sugar together in a bowl.

Heat the peanut oil in a wok. Add the ginger and the chilli and stir for 10 seconds. Toss the cucumbers in quickly, then add the rice vinegar/soy mixture. Allow to cool, then cover and refrigerate.

Boil the glass noodles until they're soft. Drain and cool.

In a bowl, gently mix the cold noodles and the cucumber sauce together.

Come and get it

Arrange a pile of noodles on the plate. Place duck pieces on top, then garnish with duck skin. Serves 8

Thai barbecued chicken with green papaya salad

1 whole chicken
4 cloves garlic, chopped
1 tablespoon chopped fresh
 coriander
2 tablespoons rice wine
2 tablespoons coconut milk
1 tablespoon nam pla
1 teaspoon chopped fresh ginger
2 tablespoons soy sauce
1 teaspoon white pepper
1 teaspoon salt

Butterfly the chicken by cutting it vertically down the breast. Combine all the other ingredients and marinate the chicken for 30 minutes.

Heat the oven or camp oven to 180°C (350°F), place the chicken on a baking pan or in the camp oven and cook for 45 minutes.

While the chicken is cooking, prepare the rice and salad.

Remove the chicken from the oven and cook on a barbecue grill or over coals for a further 15 minutes until done.

Sticky rice

4 cups (2 lb) sticky rice
water

Sticky rice

Place the rice in a bowl and cover with water. Wash the rice and drain the water several times until the water is clear, then soak it overnight or all day. Drain the rice and wrap it in a cloth. Place in a steamer and steam for 30 minutes.

Papaya salad

1 green papaya
5 cloves garlic
4 green jalapeño chillies
4 small tomatoes, cut into small
 quarters
2 tablespoons nam pla
¼ cup (2 fl oz) lime juice
salt to taste

Papaya salad

Peel the papaya and rinse in running water for a couple of minutes to remove any acid. If you can't get papaya, you can substitute carrot, but it's not as good.

Place the garlic and jalapeños in a mortar and mash until chunky. Add the tomatoes, nam pla, lime juice and salt to the mortar and combine to blend flavours.

Wine suggestion

A crisp Sauvignon Blanc Semillon blend

Come and get it

Serve chicken pieces with papaya salad and sticky rice. Serves 6

Szechuan chicken

1 whole chicken, chopped into large
 pieces (legs, breasts, wings)
peel of half a mandarin
1 tablespoon Szechuan pepper
3 tablespoons sea salt

Marinade

1 large brown onion
6 cloves garlic
2 small red chillies
2 tablespoons minced ginger
 (with skin)
½ cup (4 fl oz) light soy sauce
2 tablespoons Chinese rice wine,
 sherry or mirin
2 tablespoons honey
2 tablespoons ground Szechuan
 pepper
1 tablespoon dark sesame oil
1 tablespoon five-spice powder

Wine suggestion
A dry, fruity Gewürztraminer from
New Zealand

First make the marinade. Place the chicken pieces in a bowl, pour over marinade, add mandarin peel, mix well and allow to sit for at least 1 hour in the refrigerator.

Place the chicken pieces in an oiled baking tray and bake in a preheated oven or camp oven for 45 minutes at 180°C (350°F). Reserve the marinade.

Transfer the chicken from the oven to a hot grill. Brush the marinade on the chicken and grill until crisp and brown on the outside.

Place Szechuan pepper in a wok and cover with salt. Heat until aromatic and the salt just starts to brown. Remove from the heat, allow to cool, and then grind together in a mortar and pestle.

Marinade
Chop the onion, garlic and chillies, place in a blender with the ginger and puree into a smooth paste. (You may need to add a little water while blending.)

Add all the other marinade ingredients and pulse until well mixed.

Come and get it
Place the chicken on a serving plate, sprinkle on a little of the pepper and salt mixture and serve immediately. Serves 6

Opposite: The 'Big Red' or Nappanerica Dune, Simpson Desert, Central Australia

Lamb

Garlic-roasted leg of lamb with anchovy and rosemary

A leg of lamb is certainly a popular joint to roast. The rosy meat is sweet off the bone and basting the lamb in its own fat ensures it is soft and juicy. Lamb should be served medium rare, so the meat is pink. In this dish, incisions are made into the lamb and garlic, rosemary and anchovies are inserted, in the French Provençal style.

1 leg of lamb, about 2.7 kg (6 lb)
5 cloves garlic, sliced
45 g (1½ oz) tin anchovy fillets
24 sprigs fresh rosemary
1 tablespoon butter
¼ cup (2 fl oz) olive oil
salt and pepper

Preheat the camp oven to 200°C (390°F).

Make an incision 1½ centimetre (½ inch) deep in the top of the lamb with the tip of a knife. Stuff the hole with a slice of garlic, half an anchovy and a sprig of rosemary. Repeat this in a criss-cross pattern across the whole top of the lamb at 2½-centimetre (1-inch) intervals.

Butter the base of the camp oven and place the lamb inside. You may have to break the end of the leg bone to fit it in. Baste with olive oil and season with salt and pepper. Roast the lamb in the oven for 1¼ to 1½ hours until the meat thermometer reads 60°C (140°F) for medium rare.

Remove the meat to a plate or board, cover with a clean tea-towel and allow to rest while you make the sauce.

Sauce
¼ cup (2 fl oz) red wine
6 tablespoons butter

Wine suggestion
A sturdy, aged Cabernet Sauvignon

Sauce
Place the camp oven on top of a stove or on some coals. Skim off the fat and pour in the red wine. Bring this to the boil while scraping all the good stuff off the base and side of the oven. Whisk in the butter in small cubes and serve immediately.

Come and get it
Serve with roast vegetables. Serves 6

Previous pages: Ian Ferguson shearing at North Moolooloo Station, Flinders Ranges, South Australia

Grilled backstrap of lamb with goat's curd, pesto and roast capsicum

This is an outstanding lamb dish using the sweet backstrap fillet of lamb, which combines magnificently with the goat's curd, pesto and roasted capsicum. For lunch the next day, roll leftover roast lamb in pita or roti bread with the curd, capsicum and pesto.

4 lamb backstrap (eye of loin) fillets
2 tablespoons yoghurt
1 tablespoon chopped mint
2 large red capsicums
4 tablespoons olive oil
1 clove garlic
2 tablespoons chopped parsley
salt and pepper
250 g (9 oz) goat's curd or soft chèvre
pesto (see recipe, page 26)
6 tablespoons olive oil

Wine suggestion
A sturdy Cabernet Sauvignon

Marinate the lamb in the yoghurt and chopped mint for about two hours.

Place the capsicums either on a grill above hot coals, on a barbecue plate, or in an oven at 180°C (350°F). Turn gently with tongs, allowing the outer skin to blister and burn. Do not use a propane torch, as you want the capsicum to cook through slowly to enhance its sweetness.

When the capsicum is limp and black all over, transfer gently to a brown paper bag and seal. Leave it to sweat in the bag as it cools. When cool, take the capsicum out of the bag and carefully remove the skin. Cut it open vertically, remove the seeds and slice the flesh into strips.

Place slices of cooked capsicum in a clean bowl with its juices, olive oil, a roughly chopped clove of garlic and finely chopped parsley. Allow to marinate for a few minutes.

Place the marinated lamb on a hot grill, cook for 2 minutes on each side, then remove it from the grill and let it rest for 10 minutes.

Place the lamb in the oven for 3 minutes at 180°C (350°F).

Come and get it
Place the lamb on a plate. With a spatula or butter knife, gently spread a layer of goat's curd or soft chèvre on top of the lamb. Spoon a layer of pesto on top, then lay slices of red pepper on top of that. Serve immediately. Serves 4

Lamb shanks with harissa and couscous

8 lamb shanks
2 tablespoons flour
salt and pepper
3 tablespoons olive oil
6 cloves garlic, peeled and roughly
　　chopped
2 tablespoons tomato paste
6 large tomatoes, quartered, with the
　　skin left on
1 tablespoon oregano
1 tablespoon ground coriander
1 tablespoon ground cumin
1 tablespoon sweet paprika
generous pinch of saffron threads
1 cup (8½ fl oz) water or beef stock

Couscous
300 ml (10 fl oz) chicken stock
　　or water
300 g (10½ oz) couscous
2 tablespoons unsalted butter
1 tablespoon very finely chopped
　　parsley
salt and pepper

Wine suggestion
Cabernet Sauvignon Merlot

Roll the shanks in flour seasoned with salt and pepper.

Heat olive oil in a camp oven or oven-proof casserole, add shanks and gently cook them, turning until they are brown on all sides. Add garlic, tomato paste, tomatoes, oregano, spices and saffron while stirring. Add stock and bring the mixture gently to the boil.

Place the camp oven on coals and cook slowly for at least 2 hours. Alternatively, place the casserole in a conventional oven at 180°C (350°F). Season with salt and pepper.

Make harissa (see recipe page 52) while the shanks are cooking and prepare the couscous about 10 minutes before the shanks are done.

Couscous
Bring the chicken stock to the boil in a large saucepan. Slowly pour the couscous into the stock, stirring all the time. When all couscous has been added, put a lid on the saucepan, remove it from the heat and stand for 5 minutes.

Return the saucepan to a very gentle heat and stir the butter into the couscous, lifting it with a fork to give a light fluffy texture.

Stir in the parsley and season with salt and pepper to taste.

Come and get it
Spoon couscous in a generous heap in the centre of a plate. Top with shanks and spoon pan juices over the top. Sprinkle with fresh parsley and serve harissa on the side. Serves 4

*Previous pages: Gidgee trees in the
Simpson Desert, Central Australia*

Sweet lamb chops with pistachio mint pesto

1 cup shelled pistachio nuts
3 cups finely chopped mint
½ cup grapeseed oil
1 tablespoon mild honey
8 loin chops

Wine suggestion
A rich, oaky Chardonnay

Fry the pistachio nuts for 2 minutes in a moderately hot dry pan, taking care not to burn them. Grind them finely, but not to a meal, in a mortar and pestle.

To make the pesto, process the mint with the ground pistachios in a food processor. Place the mint and pistachio mix in a bowl and stir in the oil and honey. Mix well. Don't be tempted to add anything else (for instance, salt).

On a cast-iron griddle, seal the surface of the chops quickly to avoid the juices being drawn out. It is better with chops not to use an open flame grill, as the fat drops onto the flame and can create an inferno that will burn the outside of the meat. Cook anywhere from 6 to 10 minutes; the chops should remain pink on the inside.

Come and get it
Place the chops on a plate and top with mint pesto. Serves 4

Mushrooms

Barbecued pine mushrooms with lemon and garlic

Lactarius deliciosus, sometimes called the saffron milkcap or pine mushroom, is easily recognised. Its orange cap, gills and stem discolour green–blue when the mushroom is handled (and with age). It grows under conifers and its milk is orange, staining the cut surfaces reddish or orange. It grows in many countries around the world including Australia and North America. In Calabria it is called *rossito*. You will enjoy this recipe on one of those clear, early autumn blue-sky days when the milkcaps first appear in the pine forests, and at an afternoon barbecue when you soak up some of the last warm sunlight before winter.

¼ cup (2 fl oz) extra virgin olive oil
2 tablespoons lemon juice, freshly
 squeezed
¾ teaspoon chopped fresh thyme
¾ teaspoon chopped fresh parsley
2 cloves garlic, minced
¾ teaspoon sea salt
freshly ground black pepper
8 pine mushrooms

Wine suggestion
A rich, fruity Pinot Noir

Mix all the ingredients except the mushrooms together thoroughly.

Using a pastry brush, coat the mushrooms with the marinade and grill for about 5 minutes on a rack over coals, continuing to brush with the marinade while they cook. Serves 4

Previous pages: Gravel road through Western MacDonnell Ranges, Central Australia

Italian stuffed mushrooms baked in vine leaves

10 large fresh white mushrooms
⅓ cup (3 fl oz) extra virgin olive oil
185 g (6½ oz) sweet Italian sausage
4 cloves garlic, finely chopped
2 teaspoons finely chopped
 oregano leaves
2 teaspoons finely chopped parsley
¼ cup grated Parmigiano-Reggiano
sea salt
freshly ground black pepper
18 grapevine leaves

Wine suggestion
Either a rich Pinot Noir or an older Shiraz

Heat the oven to 200°C (390°F). Pat the mushrooms with a damp towel to remove any dirt or grit, then separate the stems from the caps. Chop the stems and reserve. Place the caps in a medium bowl and toss with 1 tablespoon of the oil.

Remove the sausage meat from its casing. Heat 2 tablespoons of oil in a small skillet over medium heat. Add the garlic, reserved mushroom stems and sausage meat. Cook until lightly browned, about 5 minutes. Stir in the oregano, parsley, Parmigiano-Reggiano and add salt and pepper to taste.

Line a camp oven or casserole with vine leaves brushed in olive oil. Place a layer of mushroom caps gill side up and spoon cooked sausage mixture into the caps. Cover with a layer of vine leaves brushed with oil. Add another layer of mushrooms filled with stuffing and cover with vine leaves brushed with oil.

Place the lid on the camp oven or casserole and bake for 30 to 40 minutes, until the vine leaves are crisp and black in parts, and the mushrooms are cooked through.

Come and get it
Serve the mushrooms and vine leaves with juice spooned over the top. Serve as a stand-alone dish (serves 5) or an accompaniment to meat or game.

Mushrooms with goat's cheese and almonds in vine leaves

This is a great summer dish. We sit in the courtyard at home under the grapevines and devour unhealthy quantities of this stuff. Don't forget to serve the crunchy vine leaves—they're the best part.

⅓ cup almonds
peanut oil
10 large fresh white mushrooms
⅓ cup (3 fl oz) extra virgin olive oil
⅓ cup finely diced onion
4 cloves garlic, finely chopped
2 teaspoons finely chopped
 oregano leaves
2 teaspoons finely chopped parsley
sea salt
freshly ground black pepper
100 g (3½ oz) crumbled feta (plain or
 flavoured) or goat's cheese
18 grapevine leaves

Wine suggestion
An autumnal Pinot Noir

Toss the almonds in a tiny bit of peanut oil, lay on a tray and roast at 180ºC (350ºF) for 5 to 8 minutes. Shake the tray every couple of minutes and watch carefully that they do not burn, as you will get little warning. In the bush, I prefer to use a wok. Place 2 teaspoons of peanut oil (because of its high flash point) in the wok and heat. Add almonds and stir-fry until they start to brown. Remove immediately and lay them on a large dish to cool, before chopping.

Heat the oven to 200°C (390°F).

Pat the mushrooms with a damp towel to remove any dirt or grit, then separate the stems from the caps. Chop the stems and reserve. Place the caps in a medium bowl and toss with 1 tablespoon of the oil.

Heat 2 tablespoons of oil in a small skillet over medium heat. Add the onion, garlic and reserved mushroom stems. Cook and stir until the stems are tender and the liquid evaporates, about 5 minutes. Stir in the almonds, oregano and parsley and add salt and pepper to taste. Transfer to a bowl and stir in the feta until the mixture is well blended.

Line a camp oven or casserole with vine leaves brushed in olive oil. Place a layer of mushroom caps gill side up and spoon the cooked feta mixture into the caps. Cover with a layer of vine leaves brushed with oil. Add another layer of mushrooms filled with stuffing and cover with vine leaves brushed with oil.

Place the lid on the camp oven or casserole and bake for 30 to 40 minutes, until the vine leaves are crisp and black in parts, and the mushrooms are cooked through.

Come and get it
Serve the mushrooms and vine leaves with pan juices spooned over the top. Serve as a stand-alone dish (serves 5) or an accompaniment to meat or game.

Native truffle fettuccine

I know the chances are you won't be able to lay your hands on a real native truffle, but this recipe works fine with ordinary mushrooms, plus (if you're feeling extravagant) a little truffle or truffle oil.

500 g (1 lb) dried fettuccine
8 native truffles
4 cloves garlic, skinned, crushed
 and chopped
3 tablespoons extra virgin olive oil
½ cup diced pancetta
½ cup finely chopped parsley
sea salt
freshly ground black pepper
½ cup shaved Parmigiano-Reggiano

Wine suggestion
Hard to go past an earthy Burgundian Pinot Noir

Cook the fettuccine in a large pot of boiling salted water until al dente, then strain through a colander. While the fettuccine is cooking, prepare the truffles by removing any grit or sand, then wash, peel and slice them thinly.

In a large pan, sauté the garlic in olive oil. Add the pancetta and fry gently until it's just crisp. Add the truffles, then immediately add the cooked fettuccine and toss with tongs. Remove from the heat. Add parsley and toss again. Season to taste with salt and pepper.

Come and get it
Heap fettuccine onto plates and top with a generous serving of shaved Parmigiano-Reggiano. Makes 4 large or 6 small servings.

First encounters with native truffles

Choiromyces aboriginum—the desert truffle, one of the rarest foods on earth—is found in the deserts of South Australia, Western Australia and the Northern Territory. The truffle appears after rain events in sandhill country. Fruiting bodies push the overlying sand up slightly, the resulting cracks providing the clue to finding it. The truffle is so rare that photos of it seem never to appear in botanical textbooks. Nevertheless, it is a traditional native food and is sometimes used by Aboriginal people as a source of water—they have a soft consistency, rather like Brie. When fresh their taste is bland, but they develop a more savoury cheesy flavour after a day or so.

Previous pages: Cattle muster at sunset,
outback South Australia
Opposite: Aerial view of Pentecost River,
Cockburn Range, the Kimberley,
Western Australia

Pesto mushrooms

500 g (1lb) mushrooms
2 tablespoons olive oil
pesto (see recipe, page 26)
walnut halves, one per mushroom

Preheat the oven to 220°C (430°F). Remove the stems from the mushrooms and discard. Brush a gratin dish or small camp oven with olive oil. Place mushrooms gill side up in the dish or oven. Spoon ½ tablespoon pesto onto each mushroom and top with one walnut half. Bake for 10 minutes.

Come and get it
Drain on a paper towel and serve as an appetiser or accompaniment.

Pine mushroom goulash with potato rösti

Rösti

1 kg (2 lb) light, floury potatoes
4 tablespoons olive oil
1 brown onion, peeled and
 finely diced
100 g (4 oz) smoked bacon, diced
 into small cubes
¼ teaspoon sea salt
1 tablespoon butter

Pine mushroom goulash

500 g (1lb) pine mushrooms
4 tablespoons extra virgin olive oil
4 cloves garlic, crushed and roughly
 chopped
½ cup chopped fresh parsley
sea salt
freshly ground black pepper

Wine suggestion

A mighty tannic, blackcurrant
Cabernet Sauvignon.

Rösti

Fill a large pot with cold water. Add the potatoes whole, with the skin on, and bring to the boil. Gently boil for 15 minutes, then remove, strain through a colander and plunge into cold water. When they are cool, remove the skins with your fingers and grate the potatoes through a mandolin.

Heat 1 tablespoon of olive oil in a cast-iron skillet, add the onion and bacon and fry until the onions are transparent and the bacon begins to brown. Remove and stir into the grated potato. Add salt and stir again.

Return the skillet to the stove with 3 tablespoons of olive oil and reheat to medium heat—not smoking hot. Add the potato and bacon mixture and gently fry, gradually patting it together with a spatula until it is incorporated as a single cake. Cook for a further 15 minutes until the base has a golden colour. Melt butter around the sides of the pan and let it soak into the rösti. While the rösti is cooking, prepare the goulash.

Invert the rösti onto a plate, then slide it back into the pan to cook the other side. Cook for a further 5 minutes until it's golden brown. Turn out onto plate and slice into portions.

Pine mushroom goulash

Clean the mushrooms by dabbing them with a wet towel, then trim the stems of any dirty ends and slice up the mushrooms.

Heat the olive oil and fry the garlic until it is fragrant. Add the sliced mushrooms and cook for 10 minutes on a gentle heat until they are cooked. Toss in the parsley and add salt and pepper to taste.

Come and get it

With a spatula, place a slice of rösti on a plate and top with spoonfuls of goulash. Serves 4

Opposite, top and bottom: Gold Coast 'one-time, speakeasy' Bar, Marree, South Australia

Grains, pulses and pasta

Bejah's rice

2 cups basmati or jasmine rice
3 cloves
2 sticks cinnamon
3–4 cardamom pods
1 medium-sized brown onion,
 finely diced
2 tablespoons butter
2 tablespoons neutral oil, such as
 light sesame oil
3 tablespoons zereshk (Iranian
 barberries), washed
1 teaspoon sugar
3 tablespoons chopped mint
½ cup pistachio nuts
½ cup pine nuts
2 tablespoons chopped coriander

Place rice in a saucepan with cloves, cinnamon and cardamom pods. Place your index finger on top of the rice and pour cold water over the rice until the water is the depth of your second finger-joint. Cover and bring to the boil, then simmer very gently for 20 minutes until the rice is dry and fluffy.

In a heavy pan, fry the onion in the butter and oil until transparent. Add the zereshk and sugar. Fry for a minute, but don't burn the sugar. Add the chopped mint, pistachio and pine nuts. Continue stirring with a wooden spoon but don't let it get too dry; add a dash of water if necessary.

Come and get it
Fold in the cooked rice, fry a little and serve immediately, topped with chopped coriander. Serves 4

Rice in the camp oven

Rice would have to be the trickiest thing to cook properly and consistently on the trail. Weather and other environmental factors all contribute to uneven heat. In inclement weather, the absorption technique is next to impossible. Over the years I have practised a failsafe method for cooking perfect rice every time in a camp oven.

2 tablespoons peanut or
 grapeseed oil
4 cups jasmine or basmati rice
6 cups (3 pints) boiling water
pinch of salt

Heat the oil in the base of the camp oven over medium heat. Add rice and stir constantly, watching the rice very carefully. The moment you detect the slightest browning of the rice, tip the boiling water in, add a pinch of salt and close the lid of the camp oven. Turn the heat down to a mild simmer. If cooking rice on a fire, place three or four small shovels of coals away from the main fire and place your camp oven on this to ensure a mild simmer. Test after 5 minutes. If the rice is not done, give it another few minutes. Serves 8

Previous pages: Sunset on William Creek–Coober Pedy Road, South Australia

Costa Rican rice

2 cups rice
3 cups (25 fl oz) water
3 cloves
2 sticks cinnamon
3 cardamom pods
4 cloves garlic
2 large brown onions, chopped
1 tablespoon coriander seeds
3 tablespoons grapeseed oil
6 baby octopuses (or 1 chicken
 breast, diced)
1 tablespoon tomato paste
½ cup (4 fl oz) lime juice
1 cup fresh coriander
sea salt
freshly ground black pepper

Wine suggestion
A lightly wooded Chardonnay

Place the rice in a saucepan and add the water, cloves, cinnamon and cardamom. Bring to the boil with the lid on, then simmer very gently for 20 minutes.

Mince 2 cloves of garlic, then fry them with the chopped onions and coriander seeds in 2 tablespoons of the grapeseed oil.

In another pan, heat 1 tablespoon of grapeseed oil, fry 2 cloves of garlic, crushed in the skin, add baby octopuses and fry, then add tomato paste. Add this to the onion mix, add the fresh coriander and allow to stand for 30 minutes.

Come and get it
Toss the octopus mix with the rice, pour over the lime juice and season with salt and pepper. Serves 4

Puy lentil cassoulade with Italian pork sausages

There are two essential ingredients in this dish. The first is quality Italian pork sausages; the second is Puy lentils, which are French, originally grown in the Auvergne at Le Puy but now also grown in Australia.

500 g (1 lb) Puy lentils
6 Italian pork sausages
2 tablespoons olive oil
2 brown onions, diced
425 g (15 oz) canned tomatoes
2 tablespoons tomato paste
1 tablespoon fresh oregano, chopped
1 large sprig thyme
600 ml (1¼ pint) beef stock
1 bay leaf
sea salt
freshly ground black pepper

Wine suggestion
Something big and red

Wash the lentils several times under cold water and remove any grit, then place them in a saucepan. Add cold water until there is about 2½ centimetres (1 inch) of water above the lentils, and slowly bring to the boil. Simmer for 15 minutes. Check to see if the lentils are soft—cooking time varies. Drain the cooked lentils into a colander.

While lentils are boiling, fry sausages in a little oil in a skillet. When cooked, cut into 2½-centimetre (1-inch) pieces.

In a camp oven, fry diced onions in olive oil until transparent. Add the tomatoes, tomato paste, oregano and thyme and mix well. Add the cooked lentils and sausage pieces and stir thoroughly. Slowly add the beef stock, then add the bay leaf and season with salt and pepper. Simmer on a low heat for 20 minutes.

Come and get it
Serve in a bowl with crusty bread—a real winter warmer. Serves 6

Previous pages: The Breakaways near Coober Pedy, South Australia

Spaghetti tossed with sun-dried tomatoes

500 g (1lb) spaghetti
sea salt
⅓ cup (3 fl oz) olive oil
6 cloves garlic crushed
1 tablespoon tomato paste
12 sun-dried tomatoes in olive oil
1 red capsicum, diced
2 tablespoons oregano
freshly ground black pepper
½ cup fresh finely chopped flat-leaf
 parsley
shaved Parmigiano-Reggiano
 to garnish

Wine suggestion
A juicy Petit Verdot

For every 500 g of dried pasta, use at least 3 litres (6 pints) of water. Place cold water in a large pot (if you use hot water from the tap it can adversely affect the flavour of the pasta). Bring to a rolling boil and add a tablespoon of salt. Add the pasta and boil till al dente. Check it after about 7 minutes. Different brands of pasta will have different cooking times.

While the pasta is cooking, heat the oil in a pan. You can add the oil from the sun-dried tomatoes for extra flavour. Fry the garlic, being careful not to let it burn. Add tomato paste, sun-dried tomatoes and capsicum. Stir constantly. Add oregano and salt and pepper to taste.

When the pasta is cooked, strain quickly and thoroughly and add it to the sauce in the pan. Stir on a medium heat, making sure you incorporate the sauce evenly through the pasta.

Throw in fresh parsley and make sure all the ingredients are thoroughly mixed.

Come and get it
Serve with grated or shaved fresh Parmigiano-Reggiano on top. Makes 4 large or 6 small servings.

Opposite top: Abandoned truck, North Moolooloo Station, Flinders Ranges, South Australia
Left: Shearing shed (detail), North Moolooloo Station

Spaghetti with the sweetest tomato sauce

500 g (1lb) spaghetti
or
2 cups unbleached plain flour
2 extra-large eggs
1½ tablespoons olive oil
1 teaspoon salt
2 tablespoons coarse-grained salt

Before starting the pasta, make the sauce.

Mound the flour on a pasta board or a wooden surface and make a well in the middle. Crack the eggs into the well and add the oil and salt. Using a fork, mix the eggs and the oil together, gradually incorporating the flour. Once you have a smooth dough, remove from the flour. Sift the remainder of the flour and discard any lumps of dough. Knead the dough for a couple of minutes, incorporating the remaining flour. Roll the dough through a pasta machine and cut to spaghetti or tagliatelle.

Bring 3 litres (6 pints) of water to the boil, add the coarse-grained salt, then add the spaghetti. If using dried commercial spaghetti, cook according to the instructions, usually about 8 minutes. If using fresh pasta, once the water is on a rolling boil, add the pasta and stir to prevent it sticking together. Place a lid on the water to return it to the boil as quickly as possible. The moment the water boils, cook the pasta for a further 15 seconds then remove. Strain through a colander.

Sweetest tomato sauce
2 tablespoons virgin olive oil
8 cloves garlic, peeled
800 g (28 oz) canned tomatoes
8 stalks of parsley
sea salt
freshly ground black pepper
1 tablespoon unbleached plain flour
¼ cup (2 fl oz) water
chopped parsley
fresh basil leaves

Sweetest tomato sauce

Heat the olive oil in a saucepan and add whole cloves of garlic. Fry until golden brown, then remove the garlic and discard.

Add the tomatoes, parsley stalks and a little salt and pepper. Place the saucepan lid ajar and reduce by half on a simmer for 30 minutes.

Run the sauce through a mouli or potato ricer on a fine setting, then return to the saucepan. Be sure to scrape all the thick sauce from the bottom of the mouli.

While bringing sauce back to boil, make a paste with the flour and water in a cup. Stir the paste into the tomato sauce when it comes to the boil. Season to taste with salt and pepper. Keep the sauce warm until ready to serve.

Wine suggestion

The blood of Jupiter—an earthy, dark-cherry coloured Sangiovese

Come and get it

Place the pasta in a bowl and top with sauce. Cover with some chopped parsley or fresh basil leaves. Makes 4 large or 6 small servings.

Spicy fruit porridge

Porridge is a much misunderstood food. It has its roots deeply entwined in ancient Anglo-Saxon culture. The Scots traditionally serve it with salt. For an extra creamy finish, aficionados will soak their oats overnight in the water in which they are going to cook them. The classics instruct us to boil the water first and then sprinkle in the oats. You can add as many different ingredients as your imagination allows. For the recipe below, try adding some raisins and nutmeg, and sweeten it with maple syrup. The main things to remember with porridge are not to burn it, to stir it constantly, and when you have served it, immediately fill the cooking container with cold water so you won't need to scour the pot when washing-up time comes around.

1 cup oats
2 cups (17 fl oz) water
4 apples, peeled, quartered and
 thinly sliced
1 teaspoon ginger, finely chopped
 or grated
2 tablespoons golden or maple syrup
1 stick cinnamon
3 or 4 pieces lemon rind
pinch of salt (essential alchemy)
brown sugar

Wine suggestion
Are you kidding? Never drink before lunch (in public).

Place all the ingredients except the sugar in a saucepan and gently bring to the boil. Make sure you stir frequently, and that the fire is not so hot as to burn the base.

Once boiled, simmer gently on the edge of the fire for about 15 minutes. When the apples are stewed soft, the porridge will be ready.

Come and get it
Place porridge in a bowl and sprinkle a teaspoon of brown sugar over the top. Serves 2

Opposite top: Prairie Hotel, Parachilna, South Australia
Left: Signs at the entrance of the Prairie Hotel

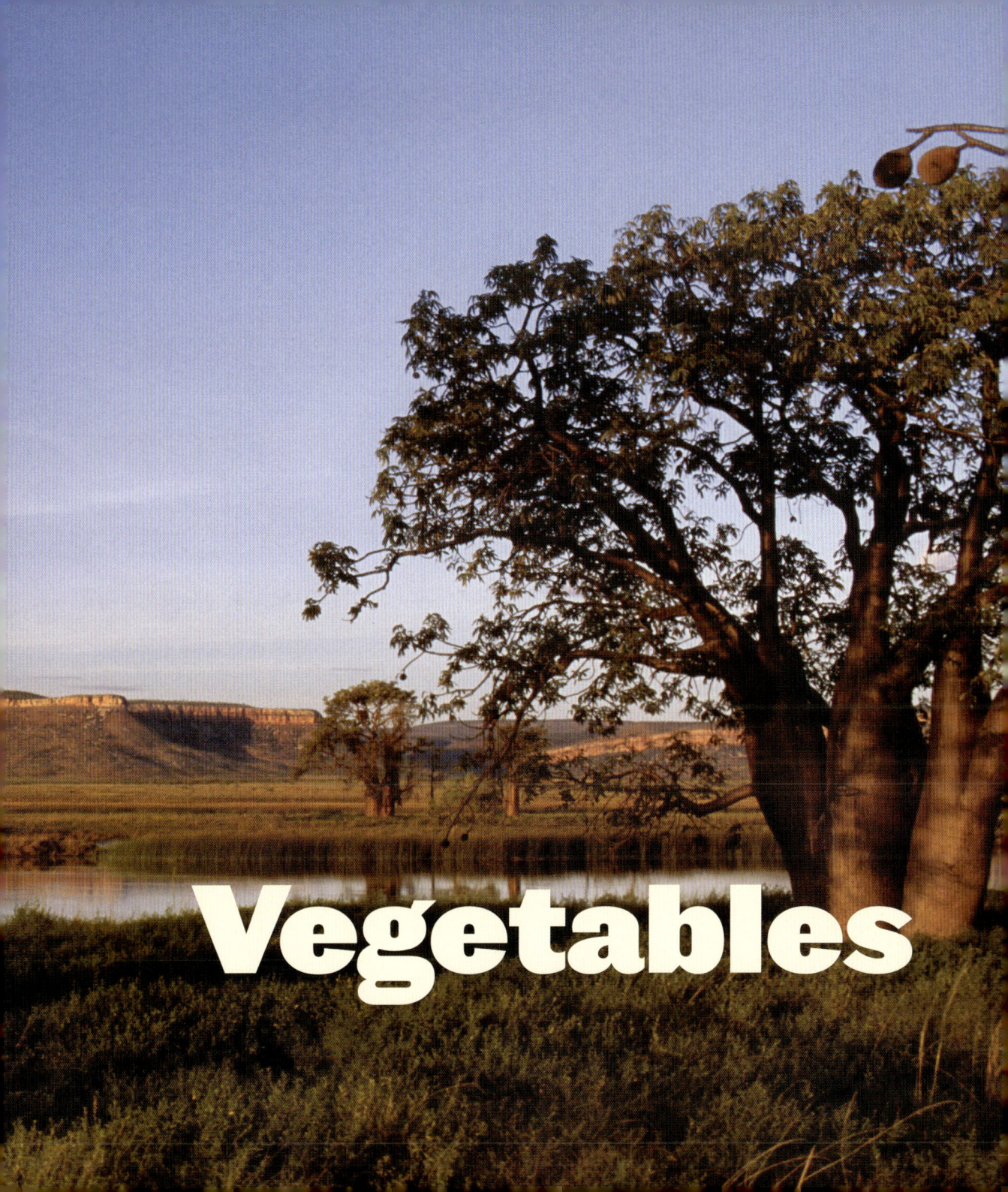

Vegetables

Artichoke with green peas and penne

1 lemon
6 globe artichokes
2 medium-sized brown onions, diced
2 cloves garlic, chopped
2 tablespoons olive oil
1 kg (2 lb) fresh or frozen peas
3 x 400 g (14 oz) cans chicken broth
12 stalks flat-leaf parsley with leaves
sea salt
freshly ground black pepper
1 kg (2 lb) dried penne pasta
2 tablespoons extra virgin olive oil
1 cup Parmesan cheese,
 freshly grated

Drink suggestion
Best to drink water.

Fill a bowl with cold water and squeeze the juice of the lemon into it. Add the lemon halves as well. This is called acidulated water and stops the artichokes discolouring.

Cut the stems off the artichokes and place them in the bowl of acidulated water. With a paring knife, pare away the bottom 5 millimetres (¼ inch) of each artichoke. Remove the hard fibrous outer leaves and cut any needles off their tips. Scoop out the hairy centre of the artichokes and cut a cross in the base 5 millimetres (¼ inch) deep. Soak the clipped artichokes in the bowl of acidulated water that already contains the stems.

Sweat the onion and garlic in hot olive oil in a camp oven or large pot.

Drain the artichokes and stems and place them in the camp oven or a large pot on the stove. Stir for 5 minutes. Cover with fresh or frozen peas and chicken broth and return to a gentle boil.

Add the parsley (leaves and stems). If the peas are not floating in the broth, top up with boiling water. Season with salt and pepper and cook over medium heat (just boiling) until cooked— about 10 minutes.

Meanwhile, in another large pot of boiling salted water, boil the penne until al dente and then drain.

Remove the artichoke flowers from the broth and set aside. Remove and discard the parsley stems.

Come and get it
Stir the cooked penne into the peas and artichoke stems with some of the stock and serve in individual bowls. Remove the artichoke flowers and serve separately in a central bowl with extra virgin olive oil. Serve Parmesan on the side.

Previous pages: Boab trees in the Kimberley, Western Australia

Ash-roasted potatoes

Potatoes are delicious roasted in their skins in the coals of the fire. No need for aluminium foil, their skins work just fine. However, if you feel like using foil, feel free. Place the potatoes away from the main flame to gently roast on the coals, turning every few minutes. Be sure you track where the potatoes are, because once they are covered with ash they will blend in with the rest of the coals. When they are ready, remove them from the coals with tongs, brush any ash off with a tea-towel and enjoy!

There are plenty of things you can add to ash-roasted potatoes. Just cut the potatoes open and top with anything you like. Here are just a few hints:

Melt slices of butter and sprinkle with chopped parsley.
Mix finely chopped rosemary with extra virgin olive oil, salt and pepper and drip on top.
Drizzle with extra virgin olive oil and slices of Parmigiano-Reggiano.
Drop on a dollop of crème fraîche and chopped chives.
Sprinkle with smoky Spanish paprika and caraway seeds.
Dress with a lemon vinaigrette.
Make an Indian raita with yoghurt, garlic, sugar, cucumber, salt, pepper and mint leaves and add a dollop.
Spoon on a tablespoon of peanut satay sauce.
Add a dollop of mayonnaise or aïoli with capers (see aïoli recipe, page 20).
Smear with crushed roasted garlic cloves.
Top with a blob of black olive tapenade (see recipe, page 26).
Fry sage leaves in extra virgin olive oil until crisp then pour over.
Top with fried onions, bacon and mushrooms.
Sauté some onion rings and place on top.
Top with pico de gallo (see recipe, page 38).
Spoon on some guacamole.
Add low-fat cottage cheese and dill.
Mix up a topping of Dijon mustard, mustard powder, grated horseradish, salt and pepper.
Drizzle with extra virgin olive oil infused with rosemary and chilli.

Bedourie braised vegetables

Flavour and colour come alive in this hearty vegetable accompaniment. Just about any root vegetable will do for this recipe, in whichever combinations suit, but onions are a must. By applying plenty of heat halfway through the braise you will make the onions ooze with that caramel sweetness that sets this dish apart. Choose potatoes that have a floury texture, preferably with a good beige colour and very fresh. Serve this dish as an accompaniment to roast meats, or on brown rice. It is delicious the next day on toast. It is essential to have all your ingredients ready before cooking.

2 large brown onions
3 large carrots
6 floury potatoes
1 kg (2 lb) pumpkin
olive oil
6 baby squash
⅔ cup (6 fl oz) water
3 tablespoons light soy sauce

Slice the onions radially into thin strips, Chinese-style. Scrub the carrots, peel them if you like, then chop them into chunky pieces. Leaving the skin on, quarter the potatoes and chop the pumpkin into large pieces.

Lay the bottom of the Bedourie oven on a side fire of hot coals and add enough oil to line the base of the oven and brown the onions. Heat until nearly smoking. Fry the onions until they are just transparent, stirring constantly with a wooden spoon. Add the carrots and toss for a minute, then add the pumpkin and toss for a minute. Add the potatoes and sit the squash on top.

Mix water and soy sauce together in a cup, sprinkle into the oven and immediately close the lid.

Lay a shovel load of coals on top of the Bedourie oven. Cook for 45 minutes or until the vegetables are done. Depending on your wood, you may need to replace the coals a couple of times. Check and stir after 15 to 20 minutes. Ideal braising temperature should be medium.

If you are using a conventional oven, use a heavy oven-proof casserole. Do the frying on the stove top, then place the casserole in a moderate oven at 180°C (350°F).

Come and get it
Serve the vegetables with pan juices spooned over the top.

Braised fennel

This dish is simple to prepare and goes wonderfully with game, pork or veal.

2 bulbs fennel
1 tablespoon butter
1 tablespoon extra virgin olive oil
1 cup (8½ fl oz) chicken broth
½ cup Parmesan cheese
1 tablespoon Pernod (optional)

Quarter the fennel and slice it into pieces 2½ centimetres (1 inch) thick. In a small camp oven, sauté the fennel in butter and oil for 5 minutes. Add the broth, cover and cook over low heat until tender, about 15 to 20 minutes.

Sprinkle with cheese and toss vigorously. You might like to add a tablespoon of Pernod just before serving.

Cajun camp oven potatoes

This is an ideal accompaniment to meat dishes and is always great at a barbecue—a real party dish.

4 tablespoons extra virgin olive oil
6 cloves garlic, peeled and crushed
2 tablespoons tomato paste
1 tablespoon Cajun spice mix
 (recipe below)
12 kipfler potatoes
sea salt
freshly ground black pepper

Cajun spice mix
2 tablespoons salt
1½ teaspoons garlic powder
½ teaspoon cayenne pepper
1½ teaspoons freshly ground
 black pepper
1 teaspoon white pepper
1 teaspoon onion powder
½ teaspoon sweet paprika
1 teaspoon cumin

In a camp oven, heat the olive oil and fry the garlic gently for a couple of minutes. Add the tomato paste and Cajun mix and continue stirring. Add the potatoes and stir until completely coated in mix. Season with salt and pepper. Put the lid on the camp oven, place on a bed of coals and shovel coals onto the lid. Bake for 45 minutes, stirring every 15 minutes.

If using a conventional oven, place the camp oven or casserole in the oven and roast at 180°C (350°F) for 45 minutes.

Cajun spice mix
Mix all the spice ingredients together and store in a jar. It will keep for a few months, but I like to mix it fresh.

Come and get it
Serve potatoes in the camp oven at the table.

Red roast camp oven vegetables

This side dish is excellent with game and rich meat dishes.

1 kg (2 lb) carrots
1 kg (2 lb) sweet potato
1 kg (2 lb) pumpkin
1 kg (2 lb) baby beetroot
4 cloves garlic, skinned and crushed
4 tablespoons olive oil
24 slices prosciutto
2 bunches asparagus spears
3 tablespoons balsamic vinegar
sea salt
freshly ground black pepper

Chop the carrots, sweet potato and pumpkin into 2½-centimetre (1-inch) cubes, leaving the skin on. Peel the beetroot.

In a camp oven, fry the garlic in 3 tablespoons of the olive oil. Add the carrots and beetroot and fry for 5 minutes, stirring regularly.

Place the lid on the oven and bake at 180°C (350°F) for 15 minutes.

Remove the lid, stir, add the sweet potato, return the lid and bake for a further 15 minutes.

Remove the lid, stir, add the pumpkin, return the lid and bake for a further 20 minutes.

Meanwhile, in a frying pan, crisp the prosciutto in 1 tablespoon of olive oil. Remove to paper towels to drain.

Remove the woody part of the stems from the asparagus. Immerse the asparagus in a saucepan of salted boiling water, cook for 1 minute and remove.

Transfer the contents of the camp oven to a large bowl and carefully incorporate the balsamic vinegar with a wooden spoon. Sprinkle with salt and pepper.

Come and get it
Carefully pile a selection of baked vegetables onto a plate. Spoon some of the pan juices over the vegetables and top with a couple of slices of prosciutto and asparagus.

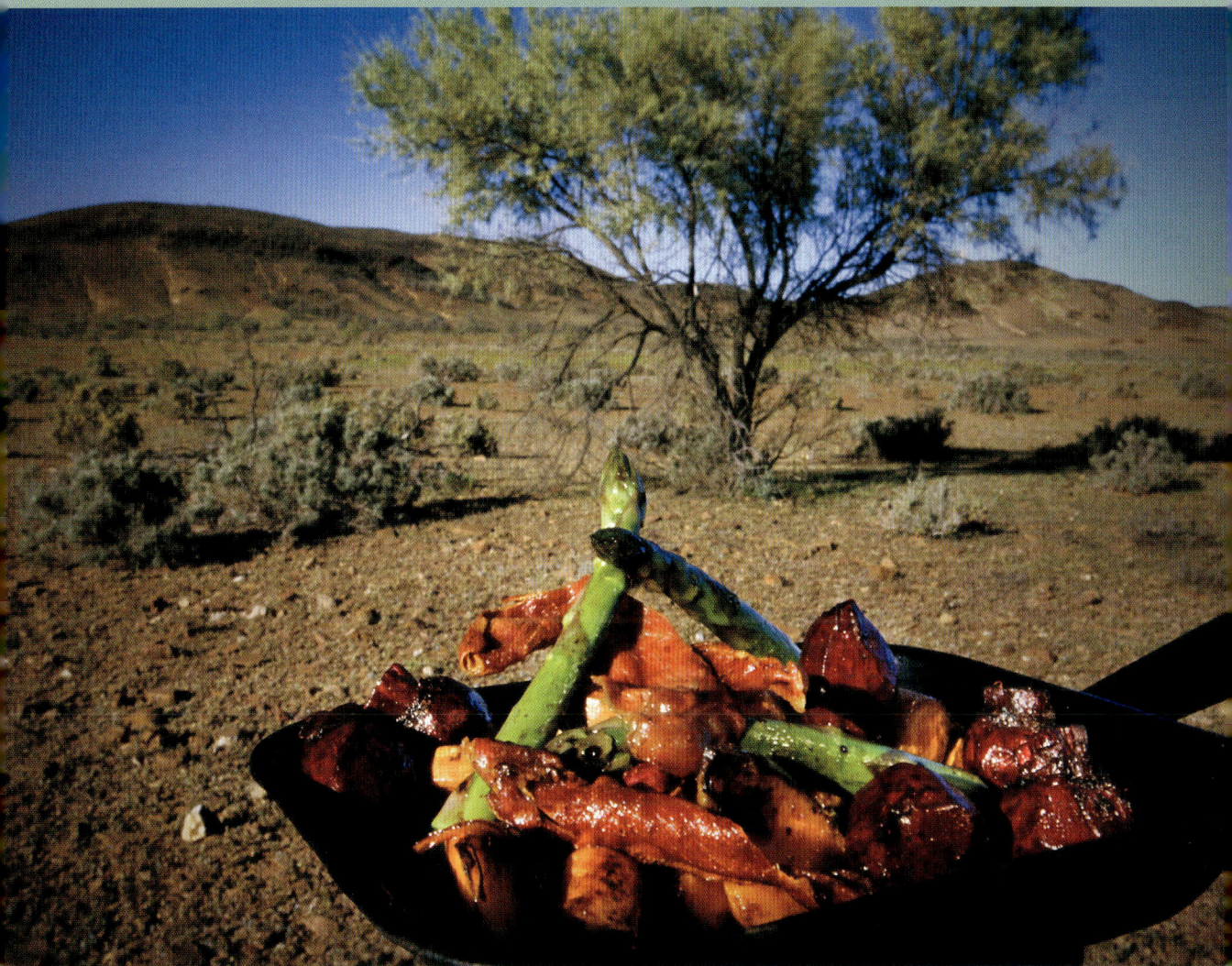

Pak boong fei deng

I have always been amazed at the lightning speed with which Thai hawkers can whip this up. On the streets of Bangkok it seriously is performance food. It only takes a few seconds to cook, and if you have your temperature right there will be an explosion of flames as the oil hits the super-heated wok. Have courage when attempting this dish—your wok cannot be too hot! That goes for the chilli too—as hot as you can bear it. In Thailand the cook asks: '*Aow ped maak mai?*' ('How spicy would you like that?') The answer is: '*Hai ped jone leum loke.*' ('Make me forget the world exists.')

Swamp spinach or water spinach is sold in bundles in Asian food stores. It also goes by the name of water convolvulus, swamp morning glory, *kang kong* in the Philippines and *rau muong* in Vietnam. Whatever name it goes by, it does not store well and needs to be eaten fresh. To preserve it, I wrap it in damp newspaper and keep it refrigerated until I need it.

In Thailand this dish is usually served with steamed jasmine rice as a quick meal. I think it goes very well with steak.

1 large bunch, about 1 kg (2 lb) water
 spinach
1 tablespoon brown bean sauce
1 tablespoon palm sugar or brown
 sugar
¼ cup (2 fl oz) Chinese peanut oil
2 tablespoons chopped garlic
as many chillies as you can tolerate,
 finely chopped
2 tablespoons nam pla

Wine suggestion
Something light and white

Place the wok on the flame and heat dry for at least 5 minutes. If you are going to cook this dish indoors, you will need a commercial-quality range hood, otherwise you will smoke the house out—or possibly burn it down!

Wash the water spinach several times. Remove the woody bottom 5 centimetres (2 inches) of stem, then cut into 5-centimetre (2-inch) lengths.

Place all the ingredients except the nam pla in a large bowl and toss well.

When you are satisfied that your wok is red hot, stand clear and hurl the contents of the bowl into it. You should get a spectacular explosion of flame. Start stirring madly for a minute or so, gradually adding the nam pla.

Roast cumin pumpkin

1 kg (2 lb) pumpkin
4 tablespoons extra virgin olive oil
1 teaspoon ground cumin
1 teaspoon cumin seeds
flaky salt
freshly ground black pepper

Leaving the skin on, cut the pumpkin into large, bite-sized chunks.

Thoroughly mix the olive oil with the ground cumin and cumin seeds and roll the pumpkin in the mix.

Place the pumpkin in a camp oven or spread on a baking tray and roast at 220°C (430°F) for 20 minutes or until golden and tender. Sprinkle with salt and pepper.

Roast Jerusalem artichokes with garlic

I just love these much-maligned and confusingly named little things. They are not artichokes but tubers, and they have nothing whatsoever to do with Jerusalem. They are closely related to, and have flowers that resemble, the sunflower. The Jerusalem part of the name is thought to be derived from the Italian word for sunflower, *girasole*.

Native to North America, Jerusalem artichokes are one of the few wild vegetables that have not been modified for our consumption. Explorer Samuel de Champlain first encountered 'sunchokes' growing in an American Indian vegetable garden in Cape Cod, Massachusetts, in 1605. He thought they tasted like artichoke—I have no idea why—and sent them to France. They turned up in England a few years later and were eaten with great gusto until superseded by the potato. On their journey of discovery through North America at the beginning of the nineteenth century, Lewis and Clarke dined on artichokes prepared by the native Indians of North Dakota.

Jerusalem artichokes have a delicate flavour, but have one major drawback. They contain a long sugar starch molecule called inulin, which can be difficult to digest and causes nasty flatulence. John Goodyer, one of the first to plant Jerusalem artichokes in England, wrote, 'But in my judgment, which way soever they be drest and eaten they stir up and cause a filthie loathesome stinking winde with the bodie, thereby causing the belly to bee much pained and tormented, and are a meat more fit for swine, than men'.

If Goodyer had been a little more patient and cooked his artichokes slowly he would have realised that the inulin is largely broken down after about 15 minutes. I have not noticed excessive flatulence with the following recipe; however, in the outback one dines outdoors …

These roasted artichokes are an ideal side dish to beef dishes.

6 cloves garlic, peeled and crushed
1 tablespoon olive oil
1 tablespoon butter
1.1 kg (2½ lb) Jerusalem artichokes
½ cup finely chopped parsley
sea salt
freshly ground black pepper

Fry the garlic in olive oil and butter in a small camp oven.

Wash the artichokes and pat them dry but leave them whole and unpeeled. Add them to the camp oven and coat with the garlic and butter.

Roast at 180°C (350°F) for 30 to 40 minutes, until the artichokes are brown and soft, stirring twice. Mix in the parsley and season with salt and pepper.

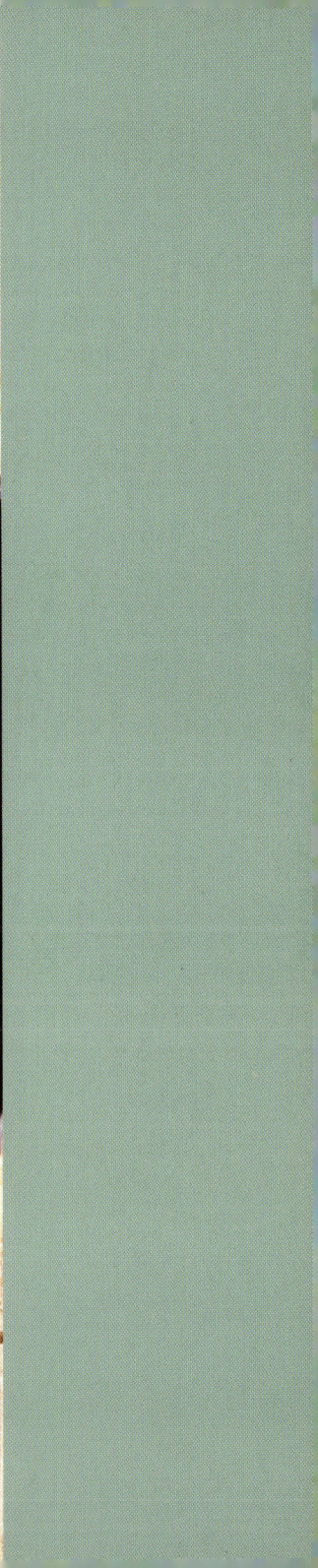

Roasted rosemary potatoes

1 kg (2 lb) potatoes
3 tablespoons extra virgin olive oil
3 large sprigs fresh rosemary
3 cloves garlic, peeled and crushed
sea salt
freshly ground black pepper

Wash and dry the potatoes thoroughly, then chop them into small chunks, leaving on the skin.

Heat the olive oil in a camp oven. Add the potatoes and cook, stirring until the outside of potatoes start to brown.

Chop half the rosemary finely, leave the rest whole, and add to the potatoes.

Add the garlic, stirring continuously, then add the salt and pepper.

Place the lid on the camp oven and place it on coals. Alternatively, roast at 200°C (390°F) for 1 hour or until golden on the outside and soft on the inside.

Spicy blachan beans

Pungent is the word that comes to mind when I think of blachan, a paste made from ground, decomposing prawns, available from Asian food stores. It smells like hell and tastes like heaven. The combination of this with the sour–sweet lime and sugar mix makes it a memorable side dish for Asian food.

500 g (1 lb) green string beans
2 tablespoons peanut oil
4 cloves garlic, skinned and crushed
1 tablespoon blachan
2 green chillies, finely chopped
½ cup (4 fl oz) fresh lime juice
2 tablespoons palm or brown sugar

Top and tail the beans and cut into 5-centimetre (2-inch) lengths.

Heat the peanut oil in a wok and stir-fry the garlic and blachan. Add the beans and chillies and stir until the beans start to colour. Add the lime juice and sugar and stir to incorporate. Turn out onto an oval plate or serve in a bowl.

Tempeh kecap

A sweet bean explosion: exotic, flavoursome, and a huge protein hit, this Indonesian-style dish is a winner with vegetarians and very handy to toss together for a dinner party. Tempeh is fermented soybean cake and is available at Asian food stores and health-food sections of some supermarkets.

2 × 300 g (10½ oz) packets tempeh
6 cloves garlic
10 abalone mushrooms
1 red capsicum
300 g (10½ oz) snow peas
3 cups (25 fl oz) peanut oil
¼ cup (2 fl oz) Indonesian kecap
 manis
3 tablespoons light soy sauce
½ cup (4 fl oz) water

Prepare the tempeh by slicing it vertically into 1-centimetre (½-inch) strips, then across into bite-sized pieces. Finely slice the garlic, rinse the mushrooms in cold water and slice the capsicum diagonally to make 3-centimetre (1-inch) diamond shapes. Top and tail the snow peas.

Heat the oil in a wok and deep fry the tempeh until it is golden brown. Remove and discard all but 3 teaspoons of oil. Drain tempeh on paper towel.

Fry the garlic, then add the mushrooms and capsicum and fry for 2 minutes.

Add the kecap manis, soy sauce and water to make a sauce consistency. The soy removes a little of the sweetness from the kecap.

Add cooked tempeh and mix well. Toss in the snow peas and stir-fry for 30 seconds to 1 minute until they're hot.

Come and get it
Serve tempeh and snow peas on a bed of rice and spoon sauce from the wok over the top.

Previous pages: Blanche Cup mound spring,
Oodnadatta Track, South Australia

Warrigal greens tossed with lemon juice and pine nuts

Warrigal greens are better known as New Zealand spinach, and were named by Captain Cook, who first discovered the plants growing on the shores of New Zealand during his epic voyage to observe the transit of Venus at Tahiti in 1770. The seed pods of this plant float on the ocean and despite being known as New Zealand spinach, the plant originated in Australia and then spread to New Zealand—and we Australians like to be quite clear about that point, not that there is any rivalry with our cousins across 'the trench'. Warrigal greens grow all over Australia, both on the coast and in the outback.

Having saved the crew of the *Endeavour* from scurvy by feeding his men this plant, Joseph Banks took it back to England where it became known as Botany Bay greens and was very popular. It appeared in seed catalogues there in the 1820s and is still grown in French market gardens outside Paris.

Warrigal greens have a high oxalate concentration. Oxalates are an organic acid considered by many to contribute to kidney stones. Only the leaves and young stems should be eaten, and it is best to blanch these in boiling water to remove soluble oxalates. It is a joy after travelling through the desert for weeks on hard tack to come across a patch of Warrigal greens, and this simple side dish takes no effort to prepare and is truly delicious. You can substitute ordinary spinach for the Warrigal greens.

1 kg (2 lb) fresh warrigal greens or
 spinach
2 cloves garlic, peeled and crushed
1 tablespoon extra virgin olive oil
50 g (1⅔ oz) unsalted butter
2 tablespoons pine nuts
juice of one lemon
½ teaspoon freshly grated nutmeg
sea salt
freshly ground black pepper

Wine suggestion
A limey Riesling

Select only the young leaves, buds and stems from the greens. Wash them several times in water to remove any grit. Drop the greens into a large pot of unsalted boiling water and boil for 3 minutes. Strain the greens and discard the water. Plunge the greens into cold water and strain again.

In a wok, gently fry the garlic in olive oil and butter. Add the pine nuts and fry until the nuts just start to brown. Add the greens and fry for 1 minute to warm them through. Add the lemon juice and nutmeg and stir to combine. Season to taste with salt and pepper.

Wok-seared wheels of corn with kecap

This is one of my all-time favourite vegetable dishes. I usually cook it as part of a smorgasbord to serve with a barbecue. I could not count the times I have sat under the stars of the Milky Way between the dunes of the Simpson Desert enjoying this with a nice blue T-bone steak and a glass of fine red wine.

2 cobs corn, as fresh as possible
¼ cup (2 fl oz) peanut oil
3 cloves garlic, peeled and chopped
1 red chilli, finely chopped
2 tablespoons Indonesian kecap
 manis
2 tablespoons light soy sauce
1 teaspoon dark sesame oil

Cut the corn into 1-centimetre (½-inch) thick wheels.

Heat the peanut oil until smoking in a wok. Stir-fry the wheels of corn until they start to blacken in spots. Add the garlic and chilli and continue stir-frying for 1 minute. Stirring continuously, add the kecap manis and soy sauce. Stir in the dark sesame oil, then remove from the heat and serve.

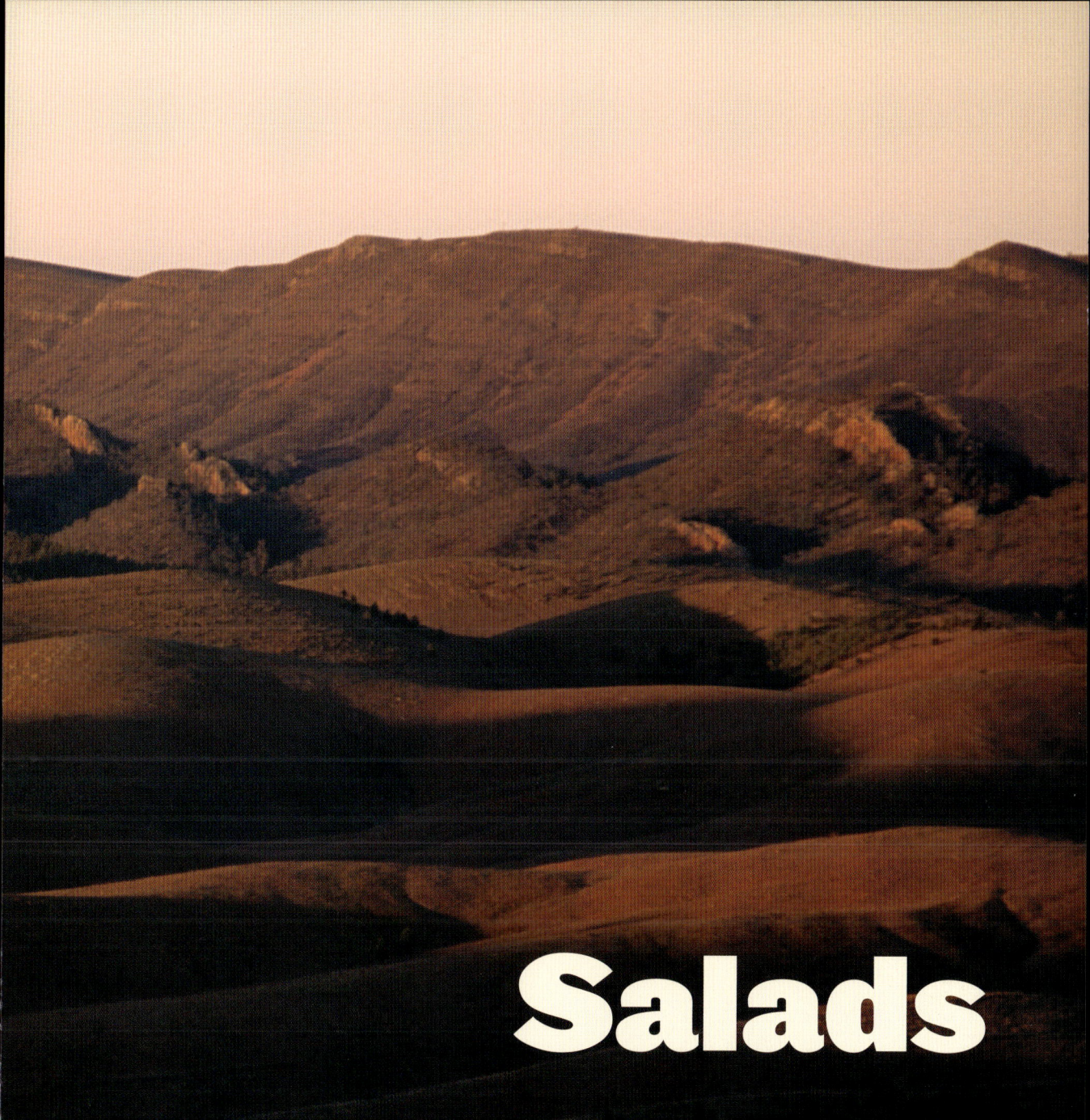

Salads

Insalata biscottata

1 clove garlic
1 cup (8½ fl oz) extra virgin olive oil
sea salt
freshly ground black pepper
10 very ripe juicy tomatoes, sliced
 into wedges
20 fresh basil leaves
1 loaf biscottata*
1 red onion

*An Italian double-baked bread or
 any hard, crusty bread

Place the clove of garlic on a fork and rub around a salad bowl vigorously.

Place the olive oil in a bowl and add salt and pepper. Squeeze the tomato wedges into the oil, mixing the juice and the oil thoroughly. Tear the basil into small pieces and add to the bowl.

In a separate bowl filled with cold water, quickly dunk small pieces of biscottata, shake dry and add to the salad. You only need to dunk the biscottata very quickly, and while it will still be hard when you add it to the salad, by the time you serve it will be the correct consistency—al dente! When all the biscottata is added, chop the onion and toss together.

Serve immediately. If you leave it to stand, the bread will be too soggy and the onion will leak into the tomato and ruin the flavour balance.

Previous pages: Sunset on the Flinders Ranges, South Australia

Rocket salad

4 tablespoons extra virgin olive oil
70 g (2½ oz) pancetta, thinly sliced
2 bunches rocket
1 tablespoon lemon juice
sea salt
freshly ground black pepper
55 g (2 oz) Parmigiano-Reggiano

Heat a tablespoon of olive oil in a skillet and sauté pancetta until crisp. Remove to drain on a paper towel.

Wash the rocket to remove any grit. In a large salad bowl, whisk lemon juice and salt, then whisk in 3 tablespoons of olive oil and freshly ground black pepper to form an emulsion. Toss the rocket in the dressing.

Top with shaved Parmigiano-Reggiano and pancetta and serve immediately.

Below: Poached egg daisies

Blanched vegetable salad

250 g (9 oz) broccoli
250 g (9 oz) cauliflower
1 red capsicum
1 yellow capsicum
1 green capsicum
1 bunch rocket
1 small lettuce
½ cup fresh sweet basil leaves, torn
½ cup chopped flat-leaf parsley

Dressing
½ cup (4 fl oz) light olive oil
1 tablespoon white wine vinegar
juice of one lemon
1 tablespoon tahini
1 teaspoon seeded Dijon mustard
1 heaped teaspoon mild-flavoured
 honey
¼ cup finely chopped parsley
sea salt
freshly ground black pepper

Fill a large pot with water and bring to a rolling boil. Add a good whack of salt. If you want the salad vividly coloured, add 3 tablespoons of baking soda as well.

Chop the broccoli and cauliflower into florets and dice the capsicum into double thumbnail-sized diamonds.

Drop the broccoli and cauliflower florets into boiling water and leave for 50 seconds, then add the capsicum. Boil for 1 minute and 20 seconds, then strain the water and immediately plunge the vegetables into iced water—speed is of the essence here.

While the vegetables are cooling, make the dressing.

Once the vegetables are well chilled, remove and drain them thoroughly. I find a salad-centrifuge is ideal, as any water on the veggies inhibits the dressing glaze.

Wash the rocket thoroughly and remove roots. Tear the leaves in half. Do the same for lettuce.

Dressing

Place all ingredients in a blender and process to a smooth, creamy texture. (By thickening with more tahini, this dressing also makes a great sauce for blanched asparagus.)

Come and get it

Toss the greens and fresh herbs with the vegetables, dress and season with salt and pepper.

Opposite, top and bottom: Woolshed at North Moolooloo Station (detail), Flinders Ranges, South Australia

Bocconcini and tomato salad

2 tablespoons extra virgin olive oil
1 teaspoon red wine vinegar
¼ teaspoon sea salt
¼ teaspoon freshly ground
 black pepper
pinch of garlic powder
6 bocconcini, halved
225 g (8 oz) cherry tomatoes, halved
8 sweet basil leaves, torn

In a bowl, whisk the olive oil, vinegar, salt, pepper and garlic powder and leave to stand for 15 minutes. Whisk the dressing again, pour over the bocconcini and tomatoes and toss with basil leaves.

Pancetta salad—an Italian Caesar

1 bunch rocket
1 yellow capsicum, sliced
2 large ripe tomatoes
10 anchovy fillets
1 cup shaved Parmigiano-Reggiano
10 slices pancetta, cut into quarters
⅓ cup (3 fl oz) extra virgin olive oil
5 tablespoons red wine vinegar
freshly ground black pepper

Wash the rocket thoroughly to remove any grit. Mix the rocket, capsicum, tomatoes, anchovies and cheese in a large bowl.

Sauté the pancetta in a skillet until crisp, then add it to the bowl of greens with olive oil and toss.

Deglaze the pan with red wine vinegar. Allow to cool, then add to the salad. Toss to combine and season with freshly ground black pepper.

Below: View of Waddi trees from the Dingo Caves, near Birdsville, Queensland. In Australia, Waddi trees grow in only two locations.

Fennel and blood orange salad

When the hot northerly wind is blowing off the Simpson Desert in summer, this traditional Italian salad is just the ticket—a cool, refreshing dish that can be enjoyed on its own for lunch.

2 blood oranges
1 bulb fennel
½ cup pitted Kalamata olives
2 tablespoons extra virgin olive oil
1 tablespoon red wine vinegar
kosher salt
freshly ground black pepper
mint leaves

Peel the blood oranges and remove all the white pith. With a paring knife, remove orange segments, strip them of their individual membranous coverings and place them in a bowl. Discard the membrane, having first squeezed any juice it may contain into the bowl.

Slice the fennel vertically into thin slices and add to bowl with the olives.

Make a dressing by mixing the olive oil and red wine vinegar, and seasoning to taste.

Toss all the ingredients together and serve topped with mint leaves.

Previous pages: Yellow top and poached egg daisies carpet Central Australia's Simpson Desert after the winter rains

Samphire salad

Samphires (*Chenopodiaceae*) are leafless plants, or glassworts, with fleshy jointed branches. They are a member of the saltbush family. They are readily found growing around salt lakes throughout Australia, and I have also seen them growing in Death Valley in California, and also in coastal Britain, where they are considered a delicacy. Samphire is quite edible, but is often very salty when eaten raw. By blanching it in boiling water you can reduce the saltiness. Unless you live on the east coast of the United Kingdom in Lincolnshire or North Norfolk, where retailers sell samphire, you will have to collect your own. It grows extensively in all states of Australia in saline areas, including coastal estuaries, salt lakes and coastal flats.

1 cup samphire
1 head broccoli
1 bunch asparagus
280 g (10 oz) snow peas
1 capsicum, chopped into bite-
 sized pieces
1 clove garlic
¼ cup (2 fl oz) extra virgin olive oil
juice of 2 limes
1 bunch rocket
freshly ground black pepper

Remove the fleshy nodes of the samphire, discarding the woody stems, and soak in cold water for 10 minutes.

Divide the broccoli into florets. Break the woody ends off the asparagus and chop it into thirds. Top and tail the snow peas. Bring a pot of unsalted water to a rolling boil, add the broccoli and asparagus and boil for a minute. Halfway into the boil, add the samphire, and about 10 seconds before taking the pot off, add the snow peas and capsicum. Strain the vegetables and quickly plunge into icy cold water. Leave to cool for a few minutes, then strain.

Meanwhile, put one clove of garlic on the end of a fork and rub the base of your salad bowl with the garlic until it leaves a waxy finish. While stirring with the garlic on the end of the fork, add the olive oil, then shortly after the lime juice. Discard the garlic and mix well. Add the rocket and the strained vegetables. Season with pepper.

Opposite, top and bottom: Outback
architecture, Marree, South Australia

String beans in olive oil and lemon

280 g (10 oz) green string beans
1 teaspoon salt
4 tablespoons extra virgin olive oil
juice of one lemon
sea salt
freshly ground black pepper
½ cup finely chopped parsley
½ cup toasted almonds, chopped
(optional)

Top and tail and string the beans, then cut them in half.

Bring 1 litre (1 pint) of water to a rolling boil and add a teaspoon of salt.

Boil the beans for 1 minute, remove, then strain through a colander and refresh in cold water.

Whisk the olive oil, lemon juice, salt and pepper together and toss the cold strained beans in the dressing.

Mix in the parsley and optional chopped almonds.

Below: Glen Helen Gorge, Western MacDonnell Ranges, Central Australia

Bakery

Barm damper in the camp oven

Ancient Egyptians used the yeast in beer as a leaven to make bread rise, and beer yeast was used in bread-making throughout Europe until the last century. Dough made with beer yeast is known as barm. Australian Coopers Ale is a good beer to use as it is naturally brewed, and due to its top-fermentation process, all the yeasts are kept as sediment. German beers are also good, as they have all-natural ingredients. Try to avoid the chemical beers.

375 ml (13 fl oz) bottle of warm beer
6 cups unbleached plain or self-
 raising flour
1 teaspoon sea salt
2 tablespoons baking powder
 (optional)
1 teaspoon olive oil
handful of coarse rock salt

Stand the stubby of beer beside the fire until it is nice and warm—around body temperature is ideal for the yeast to do its work. If you heat the beer too much you will kill the yeast. Warm your mixing bowl as well.

Mix the flour, sea salt and baking powder in a large bowl. When thoroughly blended, make a well in the centre and gradually mix the beer into the flour in a circular motion with a wooden spoon. Different flours absorb different amounts of beer. When the flour begins to form clumps and come away from the bowl, mix it with your hands until it becomes a dough. If the dough is too dry, add milk or water.

Spread a little flour on a clean work surface, turn out the dough and knead rhythmically. Kneading activates the gluten (starch) strands that give the dough its strength.

Grease a warm camp oven with oil and throw a handful of coarse rock salt into the base. Place your dough ball on top of the salt in the camp oven and leave in a warm place for half an hour or so. By this time you should detect some rising, but if not don't worry.

Place the camp oven on red-hot coals, and shovel some on the lid, but keep the oven well away from the main fire, as you don't want to burn your bread. In 30 minutes or so it should be done. Flick the top of the loaf with your thumb and forefinger. If it sounds hollow you should be right! Remember that damper cooking takes some time and practice. If you don't produce a first-rate result first time, persevere—it only gets better.

If you prefer to use the traditional method, transfer the risen dough straight to the ashes of the fire and cook in the same fashion as in the recipe for spotted dog on page 191.

Another method of cooking the dough is to roll it into sausages, put it on eucalyptus, hickory or maple twigs, brush with oil and grill over coals. Also you can roll the dough into long worms, plait them and place them over twigs.

Previous pages: Old abandoned van, Cooper Country, South Australia

Spotted dog with cocky's joy

The Irish would call soda bread with raisins and currants spotted dog. In the British navy at the time of the Napoleonic Wars, spotted dog was a kind of rice pudding with raisins and currants, and often went by the name *spotted dick*. In Australia, in the shearers' kitchen or out on the bush track, if someone had a few raisins and currants to throw into the damper, it became a spotted dog, and over the years I developed this variation on the theme. In the outback I serve this with lashings of golden syrup from the tin, as either a breakfast treat or a dessert. In the outback, golden syrup is known as cocky's joy. Wally Dowling—the last of the Canning Stock Route drovers—used to complain that it was difficult to tell the currants from the flies when he was lunching on spotted dog.

2 teaspoons dried yeast
1¼ cups (10½ fl oz) fruit juice (apple is good)
2 tablespoons sugar
1 teaspoon ginger root, grated
1 kg (2 lb) unbleached white flour
1 teaspoon salt
1 tablespoon ground cinnamon
1 teaspoon nutmeg
1 teaspoon allspice
3 tablespoons oil
juice and grated rind of one lemon
1¼ cups (10½ fl oz) warm water
1 cup currants
1 cup sultanas
1 cup raisins

Mix the yeast in a cup with ¼ cup of the fruit juice, sugar and ginger.

Mix the flour, salt, cinnamon, nutmeg and allspice together in a large bowl. Add the yeast mix to the flour and stir with a wooden spoon.

Whisk the oil with the lemon juice and rind and add to the flour and yeast mixture. Add the rest of the juice and the water to make a sticky dough. Mix in the currants, sultanas and raisins.

Sprinkle flour on your hands and tip the mixture from the bowl onto a clean work surface. Knead for a few minutes until you have a soft dough. Cover with a clean tea-towel and allow to rise for 1 hour, or until it has doubled in size, then knead the dough again.

If baking in a camp oven, place the dough in an oiled oven and allow to rise until it has doubled in size, then place the oven on coals.

If baking in the coals (my preferred method), make a large fire and wait until it has died down. If your wood is good, the coals from the previous night's campfire are ideal. With a shovel, carefully scoop out a depression in the coals large enough to place the dough in. Sprinkle white ash around this depression. Carefully lay the dough in the depression and sprinkle it with white ash, then cover with at least 10 centimetres (4 inches) of coals. Watch the mound rise as the dog cooks.

If baking in a kitchen oven, bake at 220°C (430°F) for 45 minutes.

When the dog is done, it should sound hollow when you flick it with the nail of your middle finger.

Come and get it
Slice with a serrated knife and serve with butter and a spoonful of golden syrup.

Chapatti

These flat Indian breads are a quick and handy snack out on the trail. I cooked chapatti during the great floods of 1990 when I was marooned on the Birdsville Track. They take only 15 minutes to prepare, and though they are traditionally served with Indian curries, one old bushman I know prefers his with butter and jam.

2 cups chapatti flour (ground wheat)
 or plain stone-ground wholemeal
 flour
2 tablespoons olive oil
hot water
ghee (clarified butter)
unbleached plain flour for rolling

Put the chapatti flour into a bowl, add the oil and mix. Add enough hot water to knead the mixture into a soft dough. If it is too sticky, add a teaspoon of ghee to the bowl and continue to knead. Divide the dough into walnut-sized pieces.

Heat a cast-iron frying pan or griddle until quite hot, but do not add oil, as chapatti are cooked dry.

Flatten a piece of dough between your palms and dip it in the plain flour. Roll out to a thin round chapatti, 15 centimetres (6 inches) in diameter.

Cook for 1 minute on the frying pan or griddle, turning once.

Place the chapatti on a wire rack over hot coals. At this stage the chapatti should bubble up into a round balloon. Turn chapatti quickly to avoid burning. When lightly browned on both sides, put onto a warm plate and spread with ghee. I usually melt the ghee in a saucepan and brush it on with a pastry brush. Continue piling up the chapattis until they are all cooked.

Come and get it

Serve on a warm plate with curries, or use as bread. Eat them fresh and hot, as they will not keep.

Ciabatta

This is one of my all-time favourite breads. I love dipping bite-sized pieces in olive oil. Another favourite way of eating it is to take a thick slice and spread it with orange marmalade from Seville oranges, about a teaspoon of best extra virgin olive oil and a few shavings of Parmigiano-Reggiano cheese. I am in heaven!

Starter (biga)

½ teaspoon active dry yeast
½ cup (4 fl oz) warm water
150 g (5 oz) unbleached plain flour

Dough

¾ teaspoon active dry yeast
¾ cup (6 fl oz) plus 1 tablespoon
 warm water
300 g (10½ oz) unbleached plain flour
1 teaspoon malt
1 teaspoon fine salt

Starter (biga)

Dissolve the yeast in the water in a large bowl and leave to stand for 10 minutes. Stir in the flour and mix thoroughly.

Cover the starter and allow it to remain at room temperature for 12 to 16 hours.

Dough

Dissolve the yeast in ¼ cup of the water in a large bowl and allow it to stand for 10 minutes.

Use the rest of the water (½ cup plus 1 tablespoon) to rinse the starter (biga) from its bowl and add it to the dissolved yeast.

Add the flour, malt and salt to the yeast and stir with a wooden spoon until the dough begins to come together. Knead until a soft dough is formed. Place the dough in a lightly floured bowl and allow it to rise in a warm place for 40 minutes.

Turn the dough onto a dusted work surface and cut into two. Place each piece cut side up on a clean tea-towel that has been dredged with flour, then cover with another clean tea-towel and allow to rise for 1 hour in a warm place.

Preheat the oven to 260°C (500°F) or preheat a lightly oiled camp oven on hot coals.

Place the dough in the oven and spray both the dough and the oven walls with a few squirts of water from a spray bottle. Lower the oven temperature to 220°C (430°F).

Spray the oven with water twice in the first 5 minutes, and allow the bread to bake until it browns slightly, which will take around 20 minutes. Remove to a rack and cool.

Following pages: A selection of breads baked in the outback

Anzac biscuits

A few dozen people brave the chilly autumn pre-dawn and 'stand to' in the centre of our small town on Anzac Day. The Australian flag is at half mast. The last verse of Laurence Binyon's 'For the Fallen' is read.

'They shall grow not old, as we that are left grow old …'

There is a minute's silence, the 'Last Post' and 'Reveille' are blown by whoever has a bugle, then the congregation retires to the old Baltic-pine hall for a breakfast of beef stew, tea, coffee, and—for those who have the stomach for it—a glass of dark Queensland rum. There are few dry eyes in the crowd of spectators when the returned servicemen march down the main street at 11 o'clock. After the official ceremony is over, the whole town repairs to the pub for free beer, a fine spread of food (ladies, please bring a plate), and a game of two-up out the back, where fortunes are won and lost.

Standing shoulder to shoulder in the bar with the old war heroes, one hears extraordinary stories. An old bloke once related to me how, as a prisoner of war building the infamous Burma Railway, he had been crucified by the Japanese. He survived—and after three days they cut him down. He gave a laugh. 'I'm the only bloke who ever had three days off on the Burma Railway!'

As part of the World War I war effort, women baked Scottish oatmeal cookies at home and they were sent to the soldiers fighting overseas. After the war, they were named Anzac biscuits and sold as fundraisers for returned soldiers. They are easy to bake and last well.

¾ cup desiccated coconut
1 cup unbleached plain flour
1 cup rolled oats
1 cup sugar
pinch of salt
1 teaspoon baking soda
1 tablespoon boiling water
100 g (3½ oz) butter
2 tablespoons golden syrup

Mix the coconut, flour, oats, sugar and salt together in a large bowl.

Dissolve the baking soda in boiling water. Melt the butter and golden syrup in a saucepan and add the baking soda and water mix. Pour this into the bowl of dry ingredients and combine thoroughly.

Put teaspoonfuls of the mixture on greased trays, leaving room for them to spread as they cook.

Bake in a preheated oven at 170°C (335°F) for 15 to 20 minutes until golden brown.

Allow to cool for 5 minutes, then remove from the tray and place on a wire rack to cool fully.

Opposite: Coolibah trees at sunset,
Cooper Country, South Australia

Brioche with smoked salmon, asparagus and hollandaise sauce

This is a wonderfully rich savoury combination. The left-over brioche makes the best French toast for breakfast the following day; just dip slices in a mix of beaten egg and milk and fry it in butter.

500 g (1 lb) unbleached white flour
¼ cup sugar
1 teaspoon salt
2 teaspoons dried yeast
water
5 eggs
300 g (10½ oz) butter, softened to the
 consistency of a dough

On a clean work surface, mound the flour in a ring 25 centimetres (10 inches) in diameter. Make a well in the centre. Place the sugar and the salt in the centre of the ring.

Make a smaller ring 10 centimetres (4 inches) in diameter next to the large ring. Put the yeast in the centre of that ring. Add a small amount of water to this and knead into a smooth dough. Cover the leaven dough with a cloth and leave to rise in a warm place.

Break the eggs into the well of the large ring and mix into the flour, kneading together until a dough is formed. Add a little water if it is too dry.

Place the raised leaven dough in the centre of the egg dough and knead. Knead the butter into the dough. Place the dough in a floured bowl, cover tightly with cling wrap and refrigerate for 6 hours.

Remove the dough from the refrigerator. Half-fill brioche moulds with dough and leave to rise in a warm place. When risen, paint with beaten egg and bake in a preheated oven at 200°C (390°F) for 30 minutes. When the brioche are golden, remove from the oven.

While the brioche are baking, prepare the hollandaise sauce and topping.

Hollandaise sauce

¼ cup butter
2 egg yolks, lightly beaten
1 tablespoon lemon juice
2 teaspoons water
¼ teaspoon salt
¼ teaspoon white pepper

Hollandaise sauce

Melt the butter in the top of a double saucepan with boiling water in the base. Set aside to cool. When it is cool, mix in the egg yolks, lemon juice, water, salt and pepper. Place over simmering water and heat while stirring with a wooden spoon until thickened.

To serve

8 asparagus spears
1 teaspoon baking soda
500 g (1 lb) smoked salmon
2 tablespoons finely chopped
 fresh tarragon

Wine suggestion

A lightly wooded Chardonnay

To serve

Break the woody ends off the asparagus and discard. Place the spears in a saucepan of salted boiling water for 1 minute. To make the asparagus brighter and greener, add 1 teaspoon of baking soda to the water as it comes to the boil. Strain through a colander and place in a bowl of icy cold water.

Slice the warm brioche in half. Top with rolled slices of smoked salmon and spears of asparagus. Pour hollandaise sauce over the top and sprinkle with fresh tarragon. Serves 4

Simple olive and sea-salt pizza

Another really simple pizza that you can serve with almost anything. I find that Maldon sea salt works beautifully in this recipe.

pizza dough (see recipe, page 203)
1½ teaspoons sea salt
6 sprigs fresh rosemary
20 Kalamata olives, pitted

Wine suggestion

Any red will do

With oiled hands, press the dough very thinly onto two oiled pizza trays. Sprinkle salt and chopped rosemary sprigs over the top. Place olives all over the top of the pizza in a pattern. Leave to rise for 15 minutes in a warm place.

Bake in a hot oven at 220°C (430°F) for 5 minutes. Remove from the tray and continue cooking on rack for a further couple of minutes until browned.

Come and get it

Just leave it in the centre of the table and let your guests rip it apart.

Sfincioni di patate—potato pizza

4 potatoes
¼ cup (2 fl oz) extra virgin olive oil
1 teaspoon finely chopped
 fresh rosemary
sea salt
freshly ground black pepper
pizza dough (see recipe, page 203)
3 or 4 sprigs fresh rosemary

Wine suggestion
An older Shiraz from the King Valley

Leaving on the skin, slice the potatoes and immediately place in a bowl with the olive oil, rosemary, salt and pepper. Mix well and leave to soak for half an hour.

Arrange the potato slices in a fan shape overlapping on the pizza dough. Sprinkle rosemary sprigs on top and add a little sea salt and pepper.

Bake at 220°C (430°F) or in a hot Bedourie oven for around 15 minutes, then remove from the tray and bake on a rack or tiles for a further 5 minutes until the base is firm.

Blue cheese and onion marmalade pizza

I first enjoyed this pizza in a cafe in Hopfgarten in Tyrol in Austria in the early 1980s. It was like nothing I had ever tasted. The chef used Roquefort cheese, but you can use any strong blue cheese. Start with the onion marmalade and prepare the dough while the marmalade is cooking.

Pizza dough
2 teaspoons dried yeast
1 teaspoon salt
400 g (14 oz) unbleached white flour
1 tablespoon olive oil
1 cup (8½ fl oz) water

Onion marmalade
¼ cup (2 fl oz) olive oil
6 large brown onions, finely sliced
1 sprig fresh rosemary
1 sprig thyme
1 teaspoon sugar
½ teaspoon balsamic vinegar

Blue cheese topping
280 g (10 oz) Roquefort or strong
 blue cheese
2 sprigs fresh rosemary, chopped

Wine suggestion
A Rutherglen liqueur Muscat

Pizza dough
Mix the yeast and the salt with the flour in a bowl. In another bowl, mix the olive oil with the water. Pour the liquids into the flour and beat, either with a dough hook or a wooden spoon, until a dough ball forms. On a floured board, knead the dough until it is smooth and feels like your earlobe.

Cover the bowl with a cloth and leave to rise in a warm place for 90 minutes, or until it has doubled in size.

Knead the dough again briefly and leave to rise for a further 30 minutes.

Pat the dough over an oiled pizza tray and spread evenly.

Onion marmalade
Put the olive oil and sliced onions into a saucepan and heat gently with the rosemary and thyme. Cook for 30 minutes, stirring regularly on a low heat until the onions are brown, sweet and mushy. Add the sugar and balsamic vinegar and stir.

Blue cheese topping
Spread onion marmalade over the pizza base, then crumble the blue cheese evenly on top. Sprinkle with chopped rosemary.

Bake at 220°C (430°F) until the edges of the base are crisp, then remove from the tray and bake on rack for further 5 minutes until the base is firm.

Desserts

Mandarin crepes

Crepes have been around since the Middle Ages. They come under many names—the French is *crêpe*, and the Italians call them *crespelle*. The Chinese serve rice flour crepes with Peking duck. I have made crepe batter with just flour and water. They can be made with wholemeal or white flour, chestnut flour, potato starch, buckwheat and many other variations. In the back country or on the trail they are handy things to pull out of the tuckerbox when supplies are getting low.

Crepes

500 g (1 lb) unbleached white flour
½ teaspoon salt
6 eggs, lightly beaten
600 ml (1¼ pint) water
600 ml (1¼ pint) milk
peanut oil

Place the flour in a bowl. Add the salt and mix thoroughly. Make a well in the centre of the flour and add the eggs, mixing very carefully and incorporating some of the flour. Gradually add the water and milk, fully mixing in the flour. Stir vigorously until you have a smooth batter the consistency of cream, without any lumps or chunks of dried flour.

Leave this to stand for between 20 minutes and 2 hours to allow the starch (gluten) to expand. Your batter at this stage may have become thicker, so before frying you may need to thin it out a little with a drop of water or milk.

While the batter is standing, prepare the mandarins and start the sauce.

Heat an iron or stainless-steel pan on the fire and grease with a little peanut oil. When it's hot, wipe with a paper towel. You only need the oil to coat the pan lightly. When the pan is really hot (when the oil starts to smoke), pour half a cup of batter into the centre. Swirl the batter around very quickly until it coats the pan in a very thin layer. As the batter sets, shake the pan so it does not stick. You may need to run a knife or spatula around the edges. Shake the crepe to the front of the pan, then with a quick movement forward and up, the crepe should flip and land in the pan (or the floor, or the roof, or worse still, on you!) This is not too hard—a few tries and you will have it. Alternatively, you can grab the edge of the crepe with your fingers and turn it over, or use a spatula. The crepe will only need a few moments cooking on the other side. Keep the crepes warm while cooking the rest of the batter.

Previous pages: Wheat stubble in the southern Flinders Ranges, South Australia

Mandarin sauce

8 mandarins
1 cup (8½ fl oz) water
1 cup sugar
1 star anise

Mandarin sauce

Extract the juice from half the mandarins and divide the other half into segments. In a saucepan, add the water, sugar and star anise, and place on a medium heat. Cook until it reduces by about a third, being careful not to let it burn or discolour.

Five minutes before serving, add the mandarin juice to the sugar stock. Add the mandarin segments in the last minute or so. If you leave them too long they will become sour; they just need to be heated.

Come and get it

Roll up or fold the crepes on a plate, pour the segments with some juice over the top.

Bent Suzette

For this recipe you can use the crepe recipe from page 206.

Orange butterscotch
1 orange, grated rind and juice
250 g (9 oz) butter
1 cup brown sugar

Grind the orange rind in a mortar and pestle until you have a smooth paste.

Melt the butter in a sauté pan on a gentle heat. Add the orange juice, rind and sugar on medium heat and reduce until a thick brown syrup forms, which should take around 20 minutes.

Sauce
300 ml (10 fl oz) double cream
½ cup brown sugar
½ cup (4 fl oz) Grand Marnier
1 cup (8½ fl oz) cognac or brandy

Sauce
Heat a skillet and pour in the cream and brown sugar. Stir until the sugar turns to toffee.

Come and get it
Dredge one side of the crepe in butterscotch, then roll it up. Place the crepes in the pan with the cream sauce, flame with Grand Marnier and cognac and serve immediately.

Canecutters' crepes

There has been a thriving sugar industry in tropical Queensland since colonial times, and the canecutters would slake their thirst on Queensland rum. The best known brand is Bundaberg, and goes by many nicknames, including *bundy*, *square bear* (because of the square-shaped bottle and polar bear logo), or *canecutters' cordial*. If you ask for a rum and coke in a city hotel, the bartender will usually ask, 'White or dark?' but in outback Queensland the question is always, 'With ice?' There is no other rum but the dark Queensland rum in the outback. Drovers would carry a bottle of over-proof rum in their saddlebags. One jigger in a cup of black tea would be just right after a long day in the saddle, and a bottle would last for weeks—or hours as the case may be. These crepes are called canecutters' crepes because of the sugar and the rum, and while it's traditionally a popular dessert in parts of outback Queensland, it would rarely be served by a shearers' cook because the rum wouldn't usually last long enough to cook with. Vanilla essence was also a popular drink among shearers' cooks on remote stations far from the pub.

250 g (9 oz) unbleached white flour
1 tablespoon five-spice powder
2 pinches of salt
3 eggs, lightly beaten
1 cup (8½ fl oz) milk
60 g (2 oz) butter
½ cup (4 fl oz) water

Place flour, five-spice powder and salt in a large bowl. Make a well and add the eggs.

Warm the milk in a saucepan, melt the butter into the milk, then add the water. Pour into the well, and whisk, gradually incorporating all the flour until the mixture is the consistency of pouring cream.

Heat a skillet or crepe pan till hot, brush with oil and pour half a cup of the mixture into the pan. Rotate until there is a thin coating across the pan. Turn or toss the crepe, turn out onto a plate and reserve. Cook as many crepes as you need.

Sauce
4 ripe bananas
2 tablespoons butter
2 tablespoons brown sugar
2 tablespoons Bundaberg or dark rum
4 tablespoons whipped cream

Sauce
Peel the bananas and chop into 1-centimetre (½-inch) lengths.

Melt the butter in a frying pan, stir in bananas and sugar and sauté until golden. Add the dark rum and stir.

Come and get it
Spoon some sauce into each crepe and roll up. Top with whipped cream.

Chocolate soufflé omelette

2 eggs, separated
2 tablespoons best quality
 chocolate powder (Valrhona,
 Lindt or Droste)
1 tablespoon cream
1 tablespoon milk
2 tablespoons sugar

Chocolate sauce
½ cup best quality dark chocolate
 (Valrhona, Lindt or Droste)
⅓ cup (3 fl oz) water
¼ cup sugar

Wine suggestion
Botrytis Riesling

Make the omelette mix by thoroughly blending the egg yolks, chocolate powder, cream and milk.

Whisk the egg whites— don't over-whisk or the mix will be dry— and when they are almost about to peak, add the sugar and whisk for a few more seconds. Gently fold in the egg-yolk mix.

Pour the mixture onto a lightly greased 20-centimetre (8-inch) cast-iron or non-stick pan with an ovenproof handle and bake at 200°C (400°F) for 8 minutes.

While the omelette is baking, make the sauce.

Chocolate sauce
Heat the chocolate, water and sugar until boiling, constantly stirring. Once boiled, bring down to a simmer. When the sauce is thick, it is ready to serve.

Come and get it
Slide the soufflé omelette off the pan and onto a plate, folding it in half like an omelette. Pour the chocolate sauce over and serve with fresh fruit, cream and or ice cream.

Mango with sticky rice

This is one of my favourite desserts—it is simplicity itself, with a delicate balance of flavours.

500 g (1 lb) sticky rice, soaked
　　overnight in water
2 mangoes

First sauce
1 cup (8½ fl oz) coconut cream
½ cup sugar
pinch of salt

Second sauce
1 cup (8½ fl oz) coconut cream
½ cup sugar
1 teaspoon toasted sesame seeds

Line a bamboo steamer with a wet tea-towel and lay the soaked rice out evenly.

Place the steamer over a wok full of boiling water and steam for 15 minutes.

Mix all the ingredients in the first sauce and combine with the cooked rice in a bowl. Set aside to cool.

Peel the mangoes and carefully cut into 1-centimetre (½-inch) slices.

Mix the ingredients for the second sauce.

Come and get it
Spoon the rice onto a plate and top with mango. Pour the second sauce over the top and sprinkle with toasted sesame seeds.

Neddy's stuffed figs with chocolate almond poached in port

Did you say chocolate, figs, almonds *and* port? *Bring it on*! Neddy's was about the coolest restaurant ever in the 1970s in Adelaide, South Australia, and this dessert was often on the menu. It's a dessert for those who love 'em but can't cook 'em—like me. It really is too easy, virtually fail-safe … provided you don't boil the port.

10 large dried Greek or Turkish figs
100 g (3½ oz) almonds
200 g (7 oz) dark Valrhona dark chocolate, chopped finely
½ bottle good quality sweet white port

Wine suggestion
The rest of the white port

Place the handle of a teaspoon into the hole at the top of the figs and reshape them back to their original size.

Grind the almonds and toast the meal until it is golden. Mix the chocolate and almond meal together and use it to stuff the figs.

Place the figs in a small saucepan and cover with white port. Simmer until the liquid is reduced by about half. Do not boil.

Come and get it
Place one fig in a glass jar or small glass and spoon syrup over the top.

Glossary

blachan	Known as Kapi in Thai, Belacan in Malay, blachan is a paste made from fermented shrimp. Don't be put off by the pungent odour; it is an essential ingredient in Asian cooking.
burghul	Sometimes called bulghur wheat, this is a grain staple used in North Africa and the Middle East. Unlike cracked wheat, the bran in burghul has been removed. It is commonly used in tabouleh, but can also be an accompaniment to curries.
caper	The bud of a shrubby Mediterranean plant. They range in size from the non-pareil, under 7 mm, to the grusas, larger than 14 mm. They come either preserved in salt or pickled in vinegar. To remove the salt or vinegar, rinse capers thoroughly in cold water before using.
capsicum	Known in the United States as sweet or bell peppers, capsicum can be eaten raw or cooked. I like to roast them on a rack over coals until they are blackened all over, then peel the black skin away and remove the seeds. They can then be used as a wonderful sweet ingredient for salads and sauces, etc.
celeriac	Celeriac is a root vegetable. It is a member of the celery family, and has white flesh that tastes like celery. It is a versatile food that can be cooked and mashed, chopped into salads, steamed or boiled.
chilli oil	Oil, usually peanut, olive or canola, cooked with dried chilli flakes. It is an essential condiment in Chinese Szechuan cuisine and is available from Asian food stores. Use it very sparingly—it is fiery hot.
coriander	Known as cilantro in the United States, its fresh leaves can be used in salads, dips, pestos and sauces, and the seeds in salads, curries, pastes. Ground seeds lose their flavour quickly, so are best ground and toasted as needed.
cornflour	Otherwise known as corn starch, it is the starch of the maize grain. It is used in puddings and as as a thickening agent for stir-fries and sauces.
couscous	This versatile North African staple grain is made from semolina. Classified as pasta in the United States, it is considered a grain elsewhere and is served under meat and stews in the Middle East.
golden syrup	An inverted sugar syrup easily available in Europe, Australia and Canada, but not as easy to obtain in the United States. In the US, substitute Kings syrup, a mixture of golden syrup and maple syrup. The UK brand Lyles is probably the best known worldwide.

Opposite: Crossing Central Australia's Simpson Desert, kitchen in tow

grape vine leaves	If using fresh leaves, pick medium size leaves; too old they will be tough, too young they will tear. You can buy leaves pickled in jars. These need to be blanched and plunged into cold water to remove the flavour of brine. You can freeze grapevine leaves. Blanch them for a few seconds in salty boiling water, then plunge them in iced water and dry thoroughly before freezing. They will last for up to six months in the freezer.
kecap manis	Kecap is an Indonesian sweet soy with a thicker, more syrupy texture than soy, due to a high palm-sugar content. The ABC brand is particularly good.
kudzu	Also known as 'kuzu', this is the dried root of a legume. Used by Chinese physicians to treat alcoholism, the complex starch molecules make an ideal thickener. Use as you would use cornflour.
mirin	This Japanese sweet rice wine has a culinary use similar to sherry. It can also be used as a dip with shoyu with sushi. It can also be used to remove the taste of slightly off fish. Do not use it heavily, as it has a strong flavour.
nam pla	Nam pla is the Thai name for fish sauce. The first fish sauce was manufactured in great quantities by the Romans, when it was called garum. I usually use Thai fish sauce, which is made from fermented raw fish or squid, and has a strong salty flavour. It is available from Asian food stores and most supermarkets.
olive oil	Olive oil is considered the healthiest oil because of its high content of monounsaturated fat. I only ever use virgin olive oil, which means it has been pressed mechanically and chemicals are not used in the extraction process. Extra virgin oil comes from the first pressing of the olives and contains no more than 0.8% acidity. I use this oil in salads, dips, and occasionally to cook with. Selection of oils is a matter of personal taste. I prefer a less bitter oil than some people. Selection should never relate to price.
oyster sauce	The best oyster sauce is made by cooking oysters in water until you have a thick viscous liquid. Sadly, many oyster sauces do not contain oysters at all, and are a mixture of caramel and flavour enhancers. Look carefully at the label. Oyster sauce is available from Asian food stores and supermarkets.
palm sugar	This brown sugar, made from either palmyra or coconut palm sap, has a more subtle sweetness than cane sugar.
pancetta	Italian-style pork belly that has been spiced and cured for three months. It is usually rolled.
Parmigiano-Reggiano	A hard granular unpressed cheese made from raw cows' milk. It comes from the regions of Emelia and Modena in Italy. While there are many imitation Parmesans, the genuine article is infinitely superior and is worth paying the extra for.
peanut oil	My favourite oil for deep frying, especially Asian foods and French fries. It has a very high smoke point (232°C/450°F).
pepper	In most recipes I like to use freshly ground black pepper from a mortar and pestle rather than a grinder. Asian dishes often call for white pepper; again I like it freshly ground.

pine mushrooms	Also known as saffron milkcaps, they are a deep orange mushroom that bruises blue. They grow in pine forests in Australia, Europe and America.
polenta	A versatile grain made from either white or yellow cornmeal (maize). You can buy either coarse or fine depending on how smooth you want your finished product. It is cooked like porridge or gruel, stirring constantly. Cheese or stock can be added. It can then be served as is, or can be shaped and deep or shallow fried.
porcini mushrooms	The *boletus edulis* mushroom grows wild in Europe, North America and some parts of the Middle East. In Australia we can buy it dried. Porcini have a strong nutty texture and are excellent tossed in pasta and with game.
prosciutto	This is the common term for *prosciutto crudo*, which is dry cured raw ham from the leg. The ham is packed in salt for two months, then cured for up to eighteen months.
Puy lentils	These green lentils were originally only grown on the volcanic soils in Puy, France, but they are now grown in Italy, the United States and Australia. Purists would argue that those grown in Puy are superior. They have a fresh delicate peppery flavour and remain firm after cooking.
quandong	The sweet and tart fruit of a tree of the sandlewood family that grows extensively in outback Australia. The bright red outer fruit can be eaten raw or cooked to make sauce, puree or jam. The hard inner nut or seed can be crushed and the inner kernel eaten as well. You can substitute dried apricot if quandongs are unavailable.
raspberry vinegar	Raspberry vinegar is made by infusing fresh raspberries in a mix of white wine vinegar and sugar. Served in pubs during the nineteenth century as cordial, it is great in marinades, in salads or as a refreshing summer drink. It is also available from gourmet stores.
rice vinegar	This vinegar is made from rice wine, which is alcohol fermented from the sugars in glutinous rice. Bacteria is added to convert the alcohol to acid. There are three kinds of rice wine vinegar: red, black and white. All have distinct flavours. I like to use the white as an all-purpose rice vinegar. Rice vinegars are sweeter and more delicate than regular vinegar. They are commonly available in Asian food stores and most supermarkets.
rice wine	Often known as yellow wine or Shaoxing wine, rice wine is made from fermented glutinous rice or millet and aged for at least ten years. I use the Pagoda blue label, which is available from Asian stores. You can use dry sherry as a substitute.
salt	Sodium chloride is one of the few minerals commonly eaten by humans. Sea salt is white, some rock salts can be grey, salt from northern Victoria is pink. Extensive research has shown that different salts do not differ in flavour, but it is the texture of the crystal that influences taste. One of my favourite salts is the French Fleur de sel from Brittany. I like to use the English Maldon sea salt as my general all-purpose salt, but use cheaper sea salts for preserving or salting water. I try to avoid salts containing free-flowing agents and iodine.

scallions	*see* spring onions
sesame oil	Dark sesame oil is made from toasted hulled sesame seeds. I use it as a flavouring, usually towards the end of the cooking process. It is available from Asian food stores and most supermarkets.
shoyu	Japanese soy sauce varieties differ from Chinese varieties as wheat is generally one of the primary ingredients and gives it a sweeter flavour. Shiro is the lightest, and goes well with sashimi, while tamari, with less wheat, is heavier and darker. The most common is koikuchi.
soy sauce	Good-quality soy sauce is made from fermented soy beans. There are many varieties of soy sauce from different Asian cultures. The general-purpose soy that I use most is light soy, which is made from the first pressing of the beans. Less often I use dark soy, which is thicker and has had molasses added. I only use this sauce in cooking, never as a dipping sauce.
spring onions	A member of the onion family, spring onions lack a fully developed bulb, and are milder tasting. Sometimes called scallions, eschallots or green onions. In European cookery they are generally used in salads, but in Asian cuisine they are used in sauces, marinades and soups.
Szechuan pepper	The tiny pod of an Asian fruit, and not related to pepper at all, Szechuan pepper has a sweet aromatic flavour and is used extensively in Asian cuisine.
tahini	A paste made from ground sesame seeds, originating in the Middle East. It comes either hulled or unhulled; the unhulled has a stronger flavour and is better for you, containing more vitamins, calcium and protein.
tempeh	A cake of slightly cooked soybeans that have been fermented, tempeh has greater nutritional value than tofu. It is great cut into bite-sized pieces and deep fried.
tomato paste	Also known as tomato concentrate, it can be used sparingly in sauces, generously on pizzas.
water spinach	Known in Thai as *pak boong*, in Malaysia as *kang koong*, in the US as water vongular—incidentally, it has been declared a noxious weed in Arizona and Florida. A green of the morning glory family, it stir-fries wonderfully. Substitute bok choy, mustard greens or even cos lettuce.
zereshk	The Iranian name for the small dried red fruit of the barberry bush. In Iran this is cultivated alongside saffron. It has a sour tangy sweet taste. You can substitute currants soaked in lemon juice if you have to, but Zereshk are available from Middle Eastern food stores.

Acknowledgements

My thanks to Cathy Cochrane in Boulder, Colorado, for talking me into telling my story in a book and encouraging me to get the whole thing rolling, and to John Hay, for believing so much in what I do that he came to the desert and shot all the dishes before pen had touched paper. To John Eason for lending me some of his English, and to Georgie Connan for arranging it into orderly chapters. To Siu May Dwyer, for introducing me to Asian cuisine and Ollie and Betsy Polasek, for introducing me to Eastern European cuisine and the commercial kitchen. To my sister Sally and her husband Cha for teaching me so much about regional Thai cuisine (hold the sugar). To Steve Baird, Ian Bolwell, Daryl Riley, Alan Conquer and all the Diamantina Touring Company team, who have all given beyond the call of duty to share the dream of taking people into wild places of outback Australia—beyond the bitumen—and feeding them well. My thanks for the hospitality of all the people of the outback who have helped me over the past twenty years and have become my close friends, including (but by no means exclusively): Paul Broad and Debbie Graefe at Etadunna; Ian and Karen Ferguson at North Moolooloo; John and Genevieve Hammond at Mungerannie; David and Nell Brooke; John Menzies; Wolfgang John; Theo and all the folk at Birdsville; Adam and Lynnie Plate at the Pink Roadhouse in Oodnadatta; Phil Gee of Outback Camel Safaris at William Creek; Lyall and Shirley Oldfield at the Oasis at Marree; John Read, Zoologist and Ecologist with BHP Biliton at Olympic Dam; Peter Nyaningu, Elder of the Anangu Pitjantjatjara; Jane and Ross Fargher at Parachilna; John Deckert of Westprint Maps; and Ted Egan AO, Administrator of the Northern Territory and Australian historian.

Thanks to all the Adelaide market people for their inspiration and their love of food, though I am sure to this day they don't really know what I do with their outstanding produce, including: The Marino Family; John Bugeja and the mob from Lucia's; Mark and Ian from Providore; and Connie, Fonz and Rosalie from Bottega Rotolo. Thanks to the MacErlean family, especially Bronagh for giving me a base in Adelaide to work from. To Chet Cline, for giving so generously of his time welding, designing and constructing over many years, and introducing me to and mentoring me in off-road driving. To Renata, Michael, Greg, Fonz and the team from Big Fish Workshop, who have assisted immeasurably in designing mobile commercial kitchens tough enough to function in the outback. To Krystyna for holding the reflector, washing my grubby utensils and scouring the pots in the hot and flyblown desert during an incredibly tough photo shoot. To Graeme Stoney and Wendy Jubb-Stoney, who share my love of the wild and my love of good food and to Sir Andrew and Lady Marsha Grimwade for their support, help and key role in getting me published. My thanks to the people of Jamieson, a remote community that I am proud to live in and call my home. To Tracy O'Shaughnessy for her enthusiasm for my work, and her endless patience in teaching a novice the long and complicated process of publishing a book. Finally, I would like to thank my partner in life, Jane, and our children Paddy, Jack and Rose for their endless patience, support and understanding, especially through the long and often lonely times when I was away working somewhere in the outback.

Index

Following page: View of Waddi trees from the Dingo Caves, near Birdsville, Queensland. In Australia, Waddi trees grow only in two locations.